MASTERS OF THE JAPANESE PRINT

Overleaf: 50. Harunobu. *The Descending Geese of the Koto Bridges.* 1766.

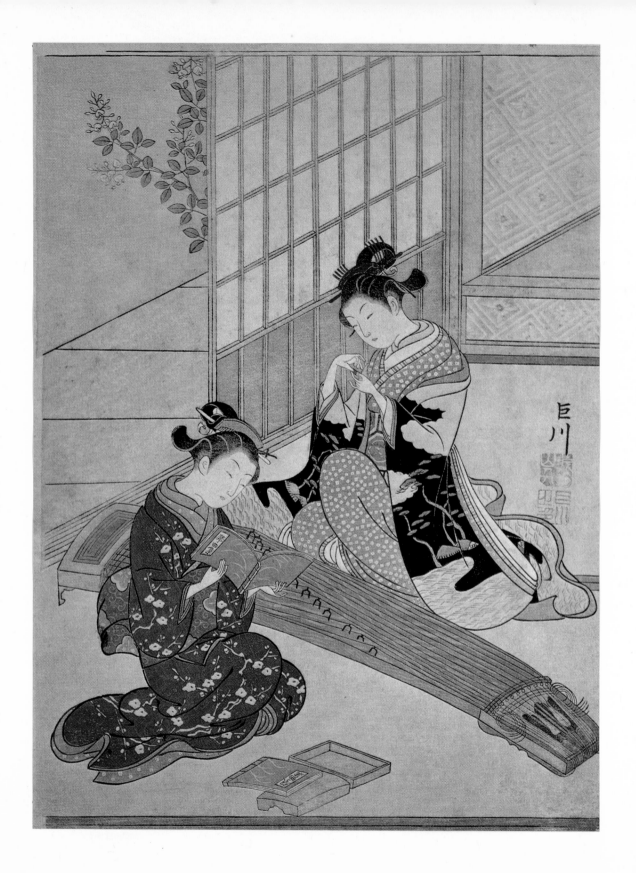

MASTERS OF THE JAPANESE PRINT

Moronobu to Utamaro

by MARGARET GENTLES

THE ASIA SOCIETY, INC. · Distributed by Harry N. Abrams, Inc.

MASTERS OF THE JAPANESE PRINT: MORONOBU TO UTAMARO
is the catalogue of an exhibition selected by Margaret Gentles
and shown in the Asia House Gallery in the autumn of 1964 as
an activity of The Asia Society, to further greater understanding
and mutual appreciation between the United States and
the peoples of Asia.

An Asia House Gallery Publication

Printed in The Netherlands

Library of Congress Catalog Card Number: 64-23784

CONTENTS

FOREWORD

Nothing, it has often been noted, is more fickle than taste in the arts. Only fifty years ago, and even less, collectors and museums were still vying for the finest impressions of the great Japanese designers of wood-block prints. One of America's most discriminating collectors, Mr. Louis Ledoux, was then bringing together the finest group of Japanese prints that could be assembled within a lifetime of effort. We now see that his achievement represents the *finale* of a long period of exploration and discovery, of comparison and selection within this delightful area of connoisseurship.

Suddenly it was all over and for the period of a generation few were interested in this material. Today, one says that the taste for the Japanese print is reviving, thanks to the interest of such enthusiasts as R. W. Robinson, Jack Hillier, and James Michener. But it may be questioned whether a renewal of collecting will actually be practical in view of the extreme scarcity of first-class material. In point of fact, it is no longer possible to purchase impressions of the majority of the prints that are here exhibited. It is nothing less than remarkable that a culture has existed in modern history with popular arts of such high quality that they now rank with the fine arts in the esteem of the fastidious yet were once nearly expended by common use.

It is thanks to Miss Margaret Gentles of The Art Institute of Chicago that this exhibition has been assembled for the Asia Society. She offers us something of a shock in telling us that it represents a first major exhibition to be held in New York City in nearly twenty-five years. We had not realized that the drought had been so severe. The choice of artists and of impressions is Miss Gentles', as is the work of cataloguing and introducing them. Together with her we are deeply indebted to the several museums and collectors who have loaned us these rare works for the occasion. It is hoped that fresh eyes will now be cast on this art by those who have loved it before and that many young ones will discover it for the first time.

Next to the Dutch, we must place the Japanese among the great masters of *genre,* masters that is to say of the poetry of everyday life. Pure genre, as Max Friedlander has pointed out, does not offer moral judgments loaded with the pedagogical weights of allegory or symbolism. Neither is it merely descriptive and anecdotal, a documentation of everyday life. Like the Netherlanders, the Japanese people always had a taste for out and out caricature, yet also like the Dutch they have often been able to rise above this popular approach. At their best, they have produced social reflections of great purity and serenity, as in the best of these prints—images that may be said to have a beauty that is not merely of sight but of vision.

It is because everyone has not taken the trouble to notice these quiet achievements, including the Japanese themselves, that these prints have sometimes been regarded as plebeian and vulgar. Time helps us to correct such misconceptions. The choice that Miss Gentles has made on this occasion emphasizes the special quality of beauty that the finest possess. Here a nobility of imagery is often discovered, even though the artist deals with themes that are conventionally judged ignoble—the figures of actors and courtesans. It was with a similar simplicity and unpretentiousness that Breughel pictured the human dignity of the peasant who, until then, had been regarded only as lout and a boor.

In both the Low Countries and Japan in the seventeenth century artists offered their countrymen scenes of the daily world merely for their contemplative enjoyment, free, that is to say, of all ulterior considerations since there is nothing in them that demands knowledge, calls for thought, or requires faith. In the best of these prints, nothing much happens and there is no social argument. We are invited simply to regard "the still point of the turning world" as T. S. Eliot called it. To quote Schopenhauer in a similar vein, such art can "bring time to a standstill".

Gordon Bailey Washburn
Director, Asia House Gallery

ACKNOWLEDGEMENTS

This exhibition makes no attempt to be a complete survey of the Japanese wood-block print. It is rather a selection from the work of the greatest masters of this art. Represented here are the artists responsible for the development of the print into a fine art, beginning with the noble black and white album sheets by Moronobu and ending with the lovely and ravishing designs by Utamaro. The selection of prints has been limited to museums and private collections in this country. I sincerely regret that time restrictions made it impossible to invite participation from the great Japanese and European collections.

I am particularly indebted to the museums and private collectors who have so generously lent their superb prints. My thanks are due to my colleagues, Jack V. Sewell, Curator of Oriental Art and Anselmo Carini, Editor of Publications, for their aid and advice; to Richard Brittain, Staff Photographer, for his special help, and to Grace Sollitt who was an invaluable critic of the text. The Japan Society has given generous assistance in translations. I am deeply indebted to the Asia Society for making this exhibition of Japanese prints possible, and to Gordon B. Washburn, Director, and his staff for the splendid installation.

Margaret Gentles
Associate Curator of Oriental Art
The Art Institute of Chicago

LENDERS TO THE EXHIBITION

The Art Institute of Chicago, Illinois

The Brooklyn Museum, New York City

Merlin and Mary Ann Dailey, Memphis, Tennessee

Fogg Art Museum, Harvard University, Cambridge, Massachusetts

Mr. and Mrs. Richard P. Gale, Mound, Minnesota

Edwin Grabhorn Collection, San Francisco, California

Honolulu Academy of Arts, Hawaii

The Metropolitan Museum of Art, New York City

The Michener Collection, Honolulu Academy of Arts, Hawaii

Museum of Fine Arts, Boston, Massachusetts

Print Division, The New York Public Library, New York City

Worcester Art Museum, Worcester, Massachusetts

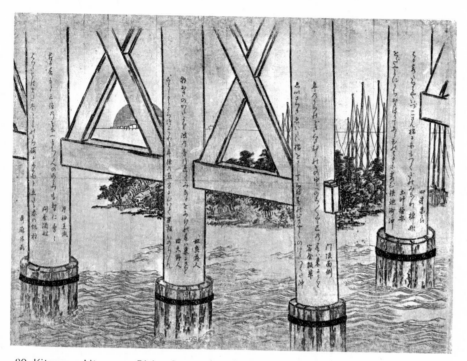

89. Kitagawa Utamaro. *Rising Sun and Tsukuda Island Seen Beneath Eitai Bridge on New Year's Morning.* 1785.

INTRODUCTION

By the middle of the seventeenth century Japan, angered by the work of the European missionaries, had cut off all foreign relations and become the whole world to her people. The long period of civil wars, when the entire nation lived in anxiety and oppression, had become legendary and the country was at peace. Edo, the city we call Tokyo, was then, as it is now, the largest city in the world and was the seat of the Tokugawa Shogunate, which actually controlled the country, while the Emperor and his effetely elegant court remained in Kyoto. Here in Edo lived the Shogun with his eighty thousand retainers, and here, every other year in turn, came by edict his great lords with their families and samurai. As might be expected, it followed that all classes of people, laborers, artisans, peddlers, merchants, artists, scholars, young men of higher social rank, flocked to Edo, all hoping to better their fortunes by catering to the needs and wants of this new and exciting city.

Now for the first time there emerged a secure middle class. They were becoming rich; they enjoyed life and were bent upon pleasure. This new class also felt a need for self-expression in art, and, since painting and the theater were the prerogatives of the aristocracy and of the Buddhist priesthood, a popular school of art came into existence. It had its beginnings in earlier genre screen and scroll

paintings concerning the joy of life and the pleasures of the day around Kyoto. The popular Kabuki theatre had developed from early puppet shows in answer to a similar need. So, now, for the citizen of Edo the woodblock print was the medium chosen to represent their interests. Impressions taken from these hand carved blocks are known to us as *ukiyo-e,* "pictures of the floating world". There is no better description of the precise meaning of *ukiyo-e* than that given by George Sansom in his *Japan: A Short Cultural History*:

"The culture of the townspeople was essentially the culture of a prosperous bourgeoisie devoted to amusement. Their arts centred round what was called in the current language of the day *Ukiyo* or the 'Floating World.' This is the world of fugitive pleasures, of theatres and restaurants, wrestling-booths and houses of assignation, with their permanent population of actors, dancers, singers, story-tellers, jesters, courtesans, bath-girls and itinerant purveyors, among whom mingled the profligate sons of rich merchants, dissolute samurai and naughty apprentices. It is chiefly the life of these gay quarters and their denizens which is depicted in popular novels and paintings of the day, the *ukiyo-sōshi* and the *ukiyo-e,* the sketch books and the pictures of the floating world."

Prints were easily reproduced by the thousands and were sold for only a few

pennies. They served the public as do our movie and fashion magazines today, and visitors to Edo could take home prints to show what was going on in the great city. They could "illustrate" their descriptions of the wondrous city with pictures of the famous courtesans dressed in the latest fashions, mighty wrestlers, and the most popular actors in their famous roles. Then, too, since the women of the Shogun's court were secluded and not permitted to go out freely, these prints eloquently told them what was going on in the famed gay quarters of Edo. This new art, this truly Japanese art of the woodblock print, pictures as nothing else could the fleeting world of fashion and fun. This was the world of the rich merchants, and, as their world revolved around the theater and the Yoshiwara, so did the subjects of their prints.

The *Ukiyo*-e artists welcomed this medium of expression and produced compositions of great merit. There was a continual freshness in the crispness of im pression, perfection of register, and the delicacy and transparency of colors in their prints. The placement of the figures, the sweep of line suggesting movement, and the amazing skill of these artists in the use of powerful black areas to bring out the importance of the action and to integrate the color scheme, resulted in a peak of artistic expression unique in the history of printmaking.

The Japanese print exerted its influence in Europe and America chiefly through a series of extraordinary exhibitions. Several of these print displays, held in Paris shortly after the middle of the nineteenth century, opened the eyes of Western

artists to the Japanese designers' employment of areas of flat color, their use of pattern, and their modulated beauty of line. Seeing these prints for the first time, Manet, Degas, Gauguin, Monet, Van Gogh, Toulouse-Lautrec, Whistler, and Mary Cassatt were profoundly inspired and refreshed. In fact, these lovely "scraps of paper" gave a new direction to European painting, and their impetus has never been forgotten. Such displays continued in Paris, culminating in the great exhibitions held annually, from 1909 to 1914, at the Musée des Arts Décoratifs. Six large illustrated catalogues were published that made history in the art world.

London was not to be left behind, and Japanese prints were shown at the Burlington Fine Arts Club in 1888. This event inaugurated a series of exhibitions that have been held in galleries and museums over the years. They may be said to have reached a climax in 1961 with the smashing centenary exhibition of Kuniyoshi at the Victoria and Albert Museum which was accompanied by R. W. Robinson's knowledgeable book on the life and work of this artist.

The first New York showing of Japanese prints was held at the Grolier Club in 1889. Eleven years after this "first", an exhibition, "The Modern Masters of *Ukiyo-e*—A Complete Historical Description of Japanese Paintings and Color Prints of the Genre School", was shown at the Fine Arts Building on 57th Street. The catalogue, describing four hundred and forty-seven prints, was by Ernest Fenollosa, Curator of the Japanese Department of the Boston Museum of Fine

Arts. Two exhibitions were held at the Grolier Club, in 1923 and 1924, with erudite catalogues by the distinguished collector, Louis V. Ledoux. In 1930 the H. O. Havemeyer Collection was put on temporary exhibition at the Metropolitan Museum, accompanied by a catalogue in which, unfortunately, only two prints were reproduced. In 1939 two men who loved Japanese art, and prints in particular, Harold G. Henderson and Louis V. Ledoux, wrote a scholarly catalogue, *The Surviving Works of Sharaku,* for an exhibition held in the Museum of Fine Arts in Boston, The Art Institute of Chicago, and the Museum of Modern Art in New York. This was the finest review to date of the work of a single master of the *Ukiyo-e* School.

The first major showing of prints in Chicago was held at The Art Institute in 1908. It was the work of four discerning gentlemen who had visited the Japanese Pavilion at the World's Columbian Exposition in 1893. Here they had been exposed to a rather undistinguished group of prints, but had come away excited enough by what they saw to start what is known as "The Chicago Craze". Clarence Buckingham, Frederick W. Gookin, J. Clarence Webster, and Frank Lloyd Wright lent six-hundred and forty-nine prints to the exhibition. The well illustrated catalogue was by Frederick W. Gookin; the epoch-making installation was designed by Frank Lloyd Wright. In 1912 a loan exhibition of prints by Hiroshige was shown at The Art Institute and Frank Lloyd Wright also wrote an appreciation, *The Japanese Print—An Interpretation,* published in Chicago that same year.

Now, almost twenty-five years after the Sharaku show, another exhibition is being held in New York to introduce a new generation to the field of Japanese prints. It might not be amiss to point out the interesting historical background of some of these prints:

MORONOBU: "Lovers" (Plate 5) was reproduced in *Chats on Japanese Prints,* 1915, by Arthur Davison Ficke, the first American to write a popular and poetic book on prints.

JIHEI: "Lady Tamamushi" (Plate 16) was exhibited and reproduced in the catalogue for the first exhibition at the Musée des Arts Décoratifs in Paris.

KIYONOBU I: "A Dancer" (Plate 22) was also reproduced in color in the above Paris catalogue. "Yaoya O-Shichi and Kichisa" (Plate 23) was reproduced in color in 1954 in *The Floating World* by James A. Michener, the second American to write a popular story of Japanese prints.

KAIGETSUDO: "Portraits of Beauties" (Plates 32 and 33) were reproduced in the Musée des Arts Décoratifs 1909 exhibition catalogue and (Plates 33 and 34) in Arthur Davison Ficke's *Prints of Kaigetsudō* published in 1923.

KIYOMASU I: "The Actor Shogōrō" (Plate 25) is from the famous French collection of Monsieur Doucet, and was reproduced in the 1909 Paris catalogue.

MASANOBU: "Large Perspective Picture" (Plate 45) from the Doucet Collection was also shown in the 1909 exhibition. "Strolling Musicians" (Plate 48) was formerly owned by John Chandler Bancroft, who first collected prints in 1863 and

later in Japan in 1896.

HARUNOBU: "A Young Girl In A Summer Shower" (Plate 49) was included in the 1909 Paris show, and was once in the collection of Charles J. Morse of Evanston, one of the earliest collectors of Japanese prints in the Chicago area. "A Breezy Day By The Sea" (Plate 53) from the famous collection of Louis V. Ledoux, was shown in the Grolier Club exhibition of 1923. "Lovers," (Plate 55) also from the Ledoux Collection was reproduced in color in the catalogue of the 1910 Musée des Arts Décoratifs exhibition in Paris.

KIYONAGA: "The Procession Of A Young Nobleman" (Plate 73) was reproduced in Chie Hirano's *Kiyonaga,* 1939, and described as the only impression known to her.

SHARAKU: "Theater Manager" (Plate 77) and Actors (Plates 78, 80-84) were all reproduced in *The Surviving Works of Sharaku* in 1940.

UTAMARO: "O-Kita" (Plate 95) was shown in the Paris exhibition of 1912 and also came from the Ledoux Collection. "Dressing Hair", "Painting Her Lips", "Girls Drying Cloth," and "The Hour of The Cock" (Plates 94, 96, 97, 98) were originally from the collection of Captain Frank Brinkley, started in Japan in 1871. "Yamauba and Kintoki" (Plate 99) was reproduced in *Utamaro,* 1961, by J. Hillier, the English author who has done much to reevaluate the Japanese print artists.

So, today, we rediscover the evanescent yet lasting beauty of the Japanese

prints, and the impress of personality, as revealed by even a cursory glance, in the art of Moronobu, Kiyonobu, Masanobu, Harunobu, Shunsho, Kiyonaga, Sharaku, and Utamaro. Moronobu gave this art the tremendous vitality of his rhythmic line; it was altered in turn by each artist as he created in accordance with his own personal vision. How the Moronobu line changed and successively reawakened in the hands of these great masters is vividly evident, and, when we look at last at Utamaro's lovely "Rising Sun on New Year's Morning" (Plate 89), we see how this artist has used his heritage. Utamaro has softened the line but it is strong, firm and flowing, and captures all the cool freshness of the sparkling newest morning of the year.

However, Utamaro's fame rests on his prints of women. They are the "pin-up" beauties of his day, these tall, elegant figures drawn with a flowing and tapering line, more human and exciting perhaps than those of his great predecessors to whom he owes so much. Utamaro is the culmination of a tradition of figure print designing from the statuesque and stately beauties of the Torii and the Kaiget-sudo, through the gentler and eloquent courtesans of Masanobu, the small exquisite girls of Harunobu, to the exalted proportions of the women by Kiyo-naga. By the force of his own genius, each of these artists created to his personal vision prints that are among the glories of *Ukiyo-e* as well as some of the most ravishing designs in the history of printing. From Moronobu to Utamaro . . . masters all.

師
宣

HISHIKAWA MORONOBU,—to 1694

Moronobu was the first artist of stature to crystallize and establish the basic style of the *Ukiyo-e* School of print making, and to make of it an art. He is sometimes spoken of as the father of pictorial printing in Japan, although illustrated books were known before his first work appeared in 1658. Moronobu was born in Hoda in the province of Awa across the far side of the bay from Edo. He was the son of a celebrated embroiderer and painter of textiles, under whose guidance Moronobu became proficient in this hereditary craft and in the art of designing for it. Around the middle of the seventeenth century he moved to Edo where he is thought to have practiced the art of embroidery for a short time while studying the Tosa and Kano styles of painting and that of the popular genre school. Moronobu was an accomplished painter, as the screens and scrolls preserved in museums in Japan and this country testify. However, as an illustrator of books and albums Moronobu had no rival. His early training doubtlessly helped to develop his fine sense of spacing in broad patterns of black and white, which together with the flexibility of his drawn line enabled Moronobu to create a visually exciting page.

Plate 1 "Daimyo and Their Retainers Before Edo Castle" is a double page from the guidebook to famous places in the city of Edo, published in 1677 and illustrated

by Moronobu. As is particularly evident in this composition, the strength of Moronobu's work lies in the vigor of his drawn line. "The Fashion of Flower Viewing at Ueno" and the two album sheets from "Views of the Yoshiwara", which could be mounted as hand scrolls, depict for us the popular pastimes of the common people. In these lively scenes one notices other characteristic elements of Moronobu's style—the groups of men inclined to flirtation, the archness of expression, the saucer-like eyebrows, the S-shape given to the figures of women, the sense of intimacy between groups and the almost electric vitality of the rendering.

Plate 2

Plates 3, 4

Plates 6-10

Moronobu designed albums of pornographic scenes but they were few in number compared to the rest of his work. In albums of this type, the first and last sheets usually show couples before and after they are in the throes of passion, as is the case in the print of "Lovers". Here, seated on the ground and sheltered by a rock and flowering plants, the young man ardently embraces his shy mistress. Moronobu's sweeping line, or "singing line" as it has been called, here creates a harmonious composition of intimacy and tenderness and his masterly use of black and white contrasts give both form and depth to the figures.

Plate 5

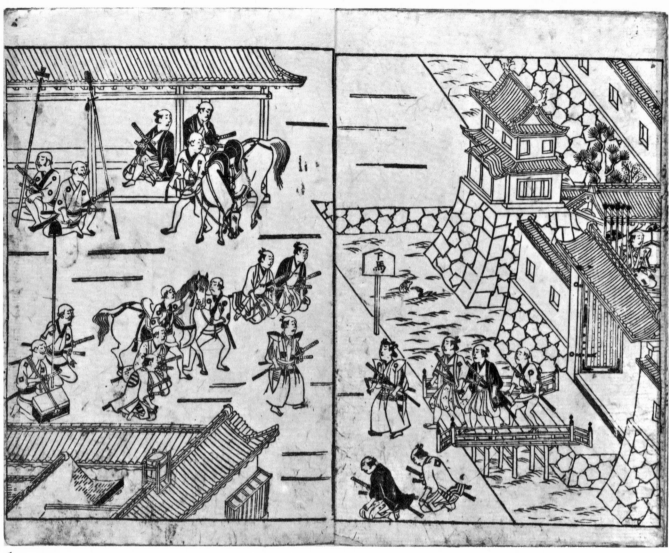

1.

4.

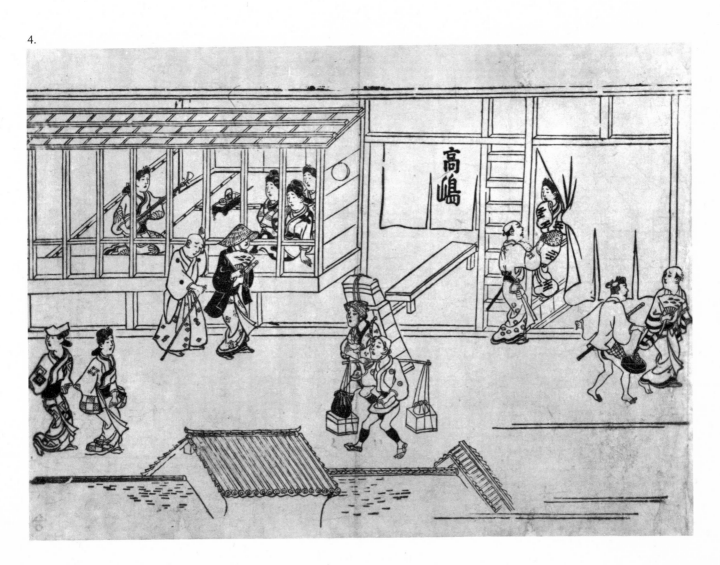

2.

3.

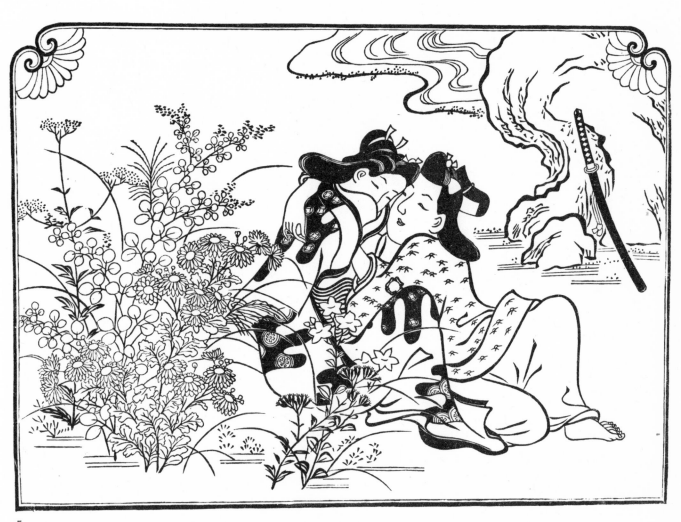

5.

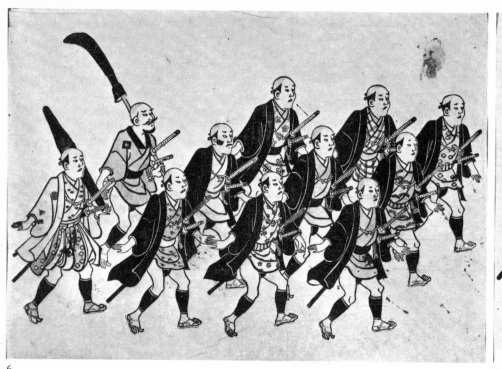

6.

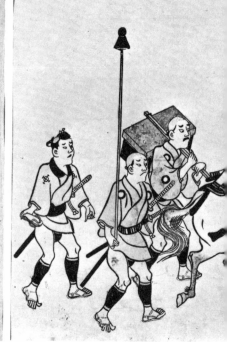

7.

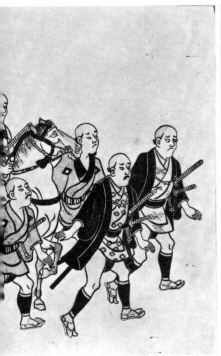

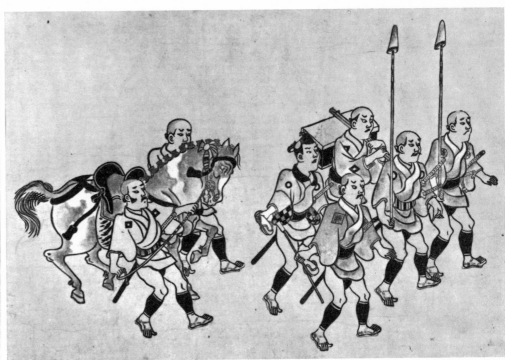

8.

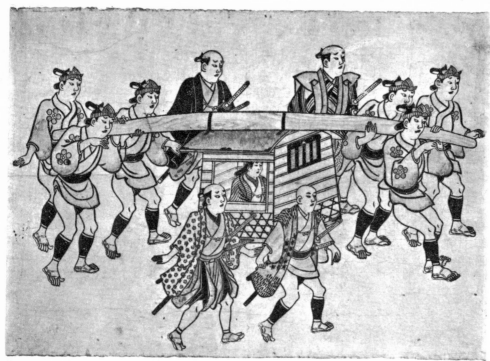

9.

10.

1. Daimyo and Retainers before Edo Castle

From the book *Edo Suzume, (The Sparrow of Edo)*.
Signature: *Eshi* Hishikawa Kichibei. 1677.
Publisher: Tsuruya.
Double page, 10⅝ x 13½ inches.

The Art Institute of Chicago—Martin A. Ryerson Collection.

A double page from a guidebook in twelve volumes illustrated by Moronobu.

2. Cherry Trees in Bloom in Ueno Park

From a set entitled "The Fashion of Flower Viewing at Ueno."
Unsigned: attributed to Moronobu. Mid-1670's.
Ink print, 10¼ x 16¾ inches.
Published: Louis V. Ledoux, *Japanese Prints of the Primitive Period in the Collection of Louis V. Ledoux,* 1942, No. 1.

The Metropolitan Museum of Art—Dick Fund, 1949.

Moronobu shows us the small-scale model of Kiyomidzu Temple in Kyoto which was erected in Ueno Park. His placement of the temple with the sheltering trees on the left, the two women admiring the blossoms, are all beautifully balanced by the two flirtatious men standing near a branching tree at the right.

3. Scene in the Yoshiwara

From a set entitled "Views of the Yoshiwara."
Unsigned: attributed to Moronobu. Early 1680's.
Ink print, 10½ x 16¼ inches.
Published: *Ukiyo-e Taika Shusei,* Vol. 1, No. 25. Louis V. Ledoux, *Japanese Prints of the Primitive Period in the Collection of Louis V. Ledoux,* 1942, No. 2.

The Metropolitan Museum of Art—Dick Fund, 1949.

Groups of people are seen near the entrance gate of the Yoshiwara. A great tub is marked "Water Tank" and on top of this are stacks of buckets in case of fire.

4. Scene in the Yoshiwara

From a set entitled "View of the Yoshiwara."
Unsigned: attributed to Moronobu. Early 1680's.
Ink print, 10½ x 14¾ inches.

Worcester Art Museum.

A fascinating print shows a street scene in the Yoshiwara before the Takashimaya, where courtesans sit behind the barred windows while one plays the samisen. Another courtesan talks to a samurai at the curtained door. Along the street pass a courtesan and attendant, a blind man feeling his way behind a samurai who hides his face under a large straw hat, tradesmen, and a samurai followed by his servant carrying a lantern.

5. Lovers

From an album of twelve sheets.
Unsigned: attributed to Moronobu. Early 1680's.
Ink print, 11½ x 13½ inches.
Published: Arthur Davison Ficke, *Chats on Japanese Prints,* 1915, Pl. I. Louis V. Ledoux, *Japanese Prints of the Primitive Period in the Collection of Louis V. Ledoux,* 1942, No. 4.

The Metropolitan Museum of Art—Dick Fund, 1949.

6-10. Procession of a Young Nobleman—Five sheets

Signature: *Eishi* Hishikawa *shin seki.* Mid-1680's.
Ink print, with later hand coloring, each sheet 10⅝ x 15 inches.
Published: *The Clarence Buckingham Collection of Japanese Prints: The Primitives.* The Art Institute of Chicago, 1955, No. 8, pp. 5 and 6.

The Art Institute of Chicago—Clarence Buckingham Collection.

In this lively procession we see black-coated samurai, grooms, and horsemen attending the young lord who is carried in a palanquin on the shoulders of porters wearing a crest similar to that of the Maeda family. It is interesting to note how Moronobu has given the feeling of movement by placing the marching men in diagonal lines and repeating the same posture in almost every figure.

枚村次平

SUGIMURA JIHEI, worked 1680's—1700

In the work of Sugimura Jihei we find a continuation of the Moronobu style. Jihei was not a pupil of Moronobu but rather a successful competitor who was inevitably influenced by the extraordinary talent of his contemporary. Like Moronobu, Jihei was a prolific illustrator of picture books and albums, largely *Plate 12* erotic, that appealed to the popular tastes of the period.

Not until the great Japanese collector and scholar Kiyoshi Shibui published his book on early *Ukiyo-e* albums, in 1926, did we find the work of Jihei emerging into focus and becoming more than just a name in Japanese biographies. We now know that Jihei's first signed and dated picture book appeared in 1681 and his last dated work in 1697. We learn that, although an album of twelve sheets might appear to be unsigned, Jihei had a way of signing his prints and albums by *Plate 13* working the characters for part or all of his name into the decorative patterns appearing on the robes and sashes worn by his figures. Indeed many of the *Plates 14, 15* unsigned masterpieces formerly ascribed to Moronobu are found to be the work of Jihei. It is almost unbelievable that this artist, the rival of Moronobu and a man whose work was in such great demand, could have remained unrecognized for so long.

Plate 14 Jihei's finest work in his fully developed style dates from around the mid-1680's, when Moronobu was similarly at the height of his power. One feels an intimacy and urgency in the figures of Jihei, and an astringent quality that produces an almost disturbing power. His use of a screen to shelter his lovers and *Plate 11* to offset the voluptuous curves of the figures as well as his ability to create the bold kimono patterns popular at this time, clothing the figures in sweeping folds of unfaltering line, are all distinguishing marks of a master.

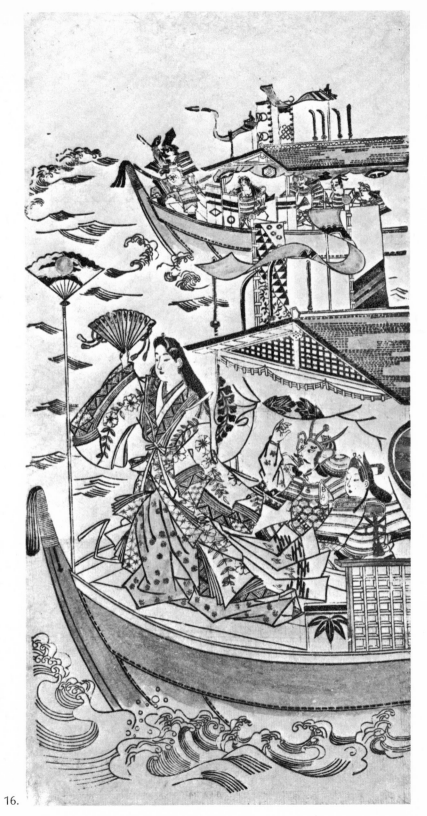

16.

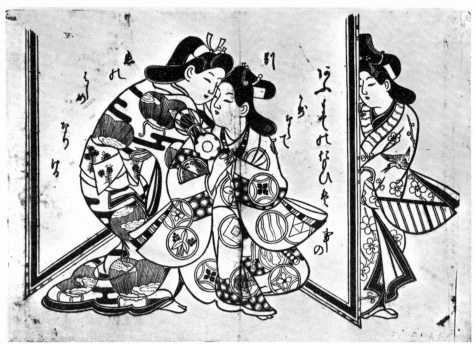

11.

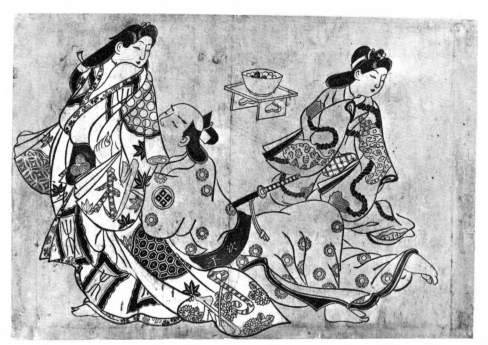

13.

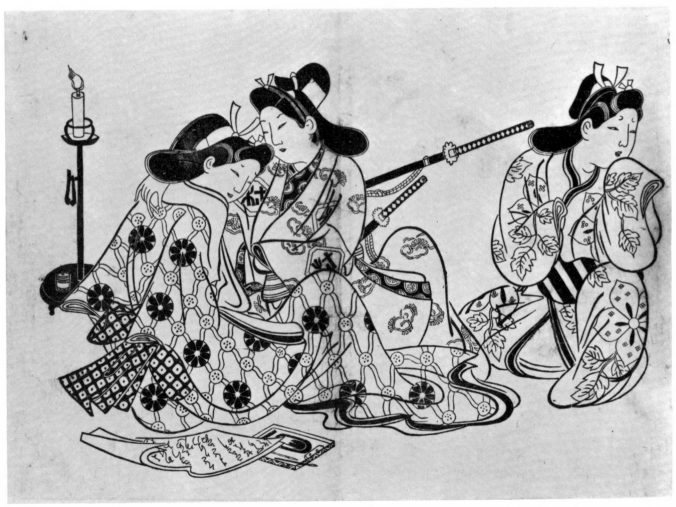

12.

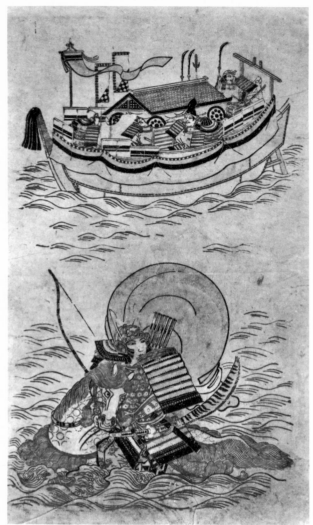

15.

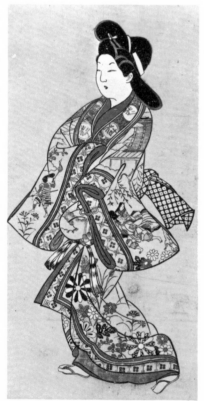

14.

11. Lovers by a Screen

Unsigned: attributed to Sugimura. Mid-1680's.
Ink print, 10½ x 14½ inches.
Published: J. Hillier, *Japanese Masters of the Colour Print*, 1954, Pl. 3. James A. Michener, *Japanese Prints from the Early Masters to the Modern*, 1959, No. 13, p. 31.

From the Michener Collection, Honolulu Academy of Arts.

The poem on the screen as translated by Richard Lane reads: "my longings ere we met are as naught: parting is indeed the beginning of love."

12. Lovers with Maidservant

Signature: Mura (the characters appear as a crest on the man's robe). Mid-1680's.
Ink print, 10¾ x 15½ inches.
Published: Louis V. Ledoux, *Japanese Prints of the Primitive Period in the Collection of Louis V. Ledoux*, 1942, No. 5.

The Metropolitan Museum of Art—Dick Fund, 1949.

13. Lovers with Maidservant

Signature: Sugimura Jihei (the characters appear on the design of the girl's robe and the man's belt). Mid-1680's.
Ink print with hand coloring, 10¾ x 16 inches.
Published: *The Clarence Buckingham Collection of Japanese Prints: The Primitives*, The Art Institute of Chicago, 1955, color plate, p. 20.

The Art Institute of Chicago—Clarence Buckingham Collection.

14. Strolling Woman

Signature: Sugimura (the characters appear on the collar of the robe). Late 1680's.
Ink print with hand coloring, 22½ x 11⅛ inches.
Published: J. Hillier, *The Japanese Print a New Approach*, 1960, Pl. 2.

The Art Institute of Chicago—Clarence Buckingham Collection.

15. The Archer, Yasu no Yoichi at the Battle of Yashima

Unsigned: attributed to Sugimura. Mid-1690's.
Ink print with hand coloring, 21½ x 13 inches.
Published: Edwin Grabhorn, *Figure Prints of Old Japan,* printed for The Book Club of California, 1959, No. 3.

Edwin Grabhorn Collection, San Francisco.

When the famous archer, Yasu no Yoichi, was ordered by Minamoto no Yoshitsune to shoot the fan set up as a target in the prow of the Taira ship, the incident marked the beginning of the battle of Yashima in 1185 between the two powerful clans. This and the following print were formerly attributed to Moronobu.

16. Lady Tamamushi Holding her Fan in the Prow of a Boat at the Battle of Yashima

Unsigned: attributed to Sugimura. Mid-1690's.
Ink print with hand coloring, 22³/₈ x 11³/₄ inches.
Published: *The Clarence Buckingham Collection of Japanese Prints: The Primitives,* The Art Institute of Chicago, 1955, No. 13, p. 12.

The Art Institute of Chicago—Clarence Buckingham Collection.

清信

清
信

TORII KIYONOBU I, 1664—1729

Kiyonobu's father, an Osaka actor and a painter of theatrical signboards, was his first teacher. The father and son are said to have come to Edo in 1687 where Kiyonobu immediately began to illustrate books showing the influence of Moronobu, although he had not been his pupil.

Plate 19 — Kiyonobu is the founder of the Torii line who were the artists for the Kabuki theaters, specializing in the painting of posters and signboards, the designing of playbills and actor prints. It was around 1695 that his large, single-sheet actor prints began to attract attention. In these prints one can see his special aptitude for the bold, fluid line, a necessity in the painting of theatrical posters. Kiyonobu also gave a new direction to the print movement by turning away from street

Plates 20, 23, 24 — scenes and views in the Yoshiwara to the Kabuki theater. In this field the style of Kiyonobu dominated for nearly seventy-five years until Shunshō appeared on the scene.

In 1700 two albums by Kiyonobu were published, one on courtesans and the

Plates 17, 18 — other on actors. From these sheets one can see the fully developed style of this artist in treating two different themes. Kiyonobu was a great artist with a fine sense of spacing flat patterns that are held within a bold outline. But it is for the

Plate 22 — powerful and dramatic sweep of line itself that one remembers his genius.

19. *The Actor Sawamura Kodenji as a Woman at the Time of the Tanabata Festival.* 1698.

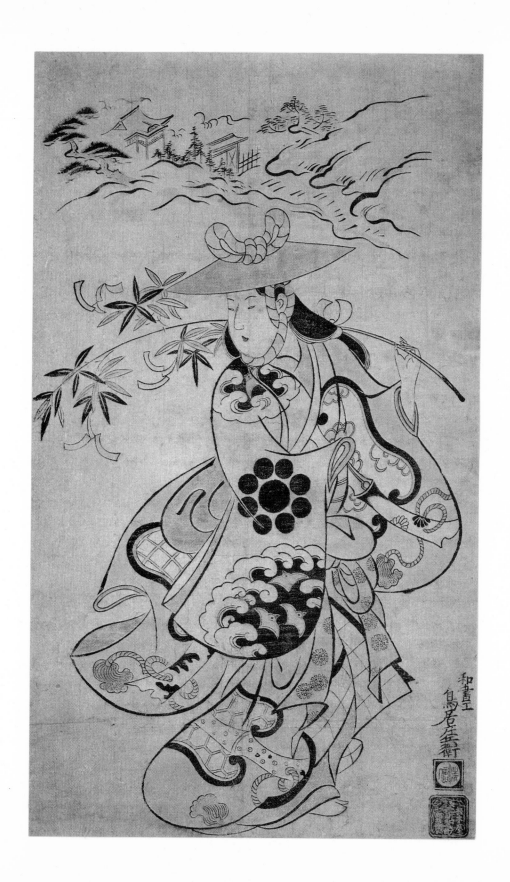

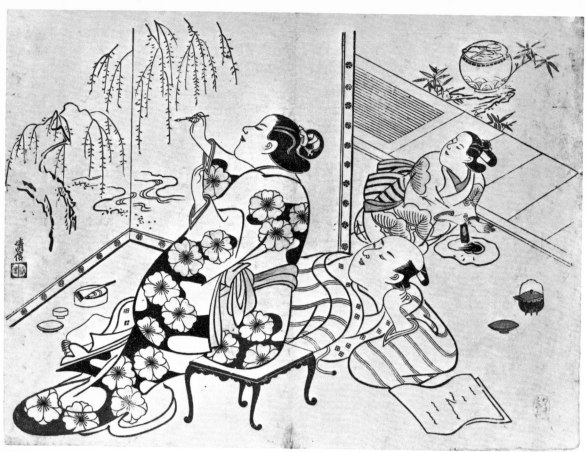

21.

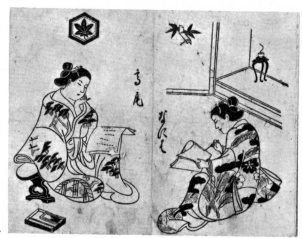

17.

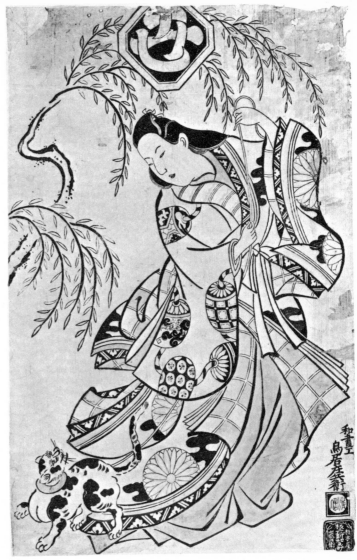

20.

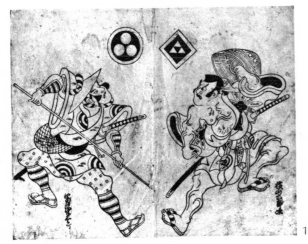

18.

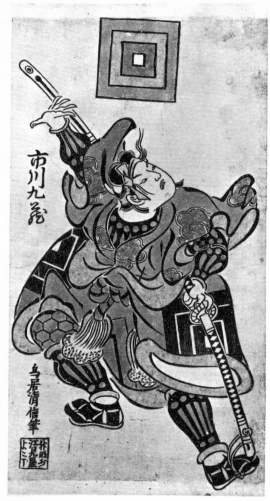

24.

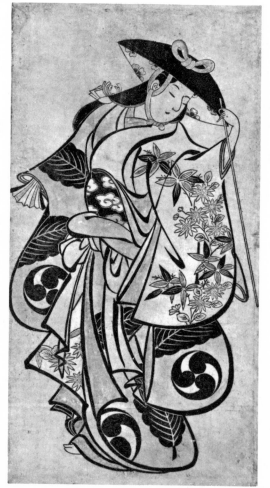

22.

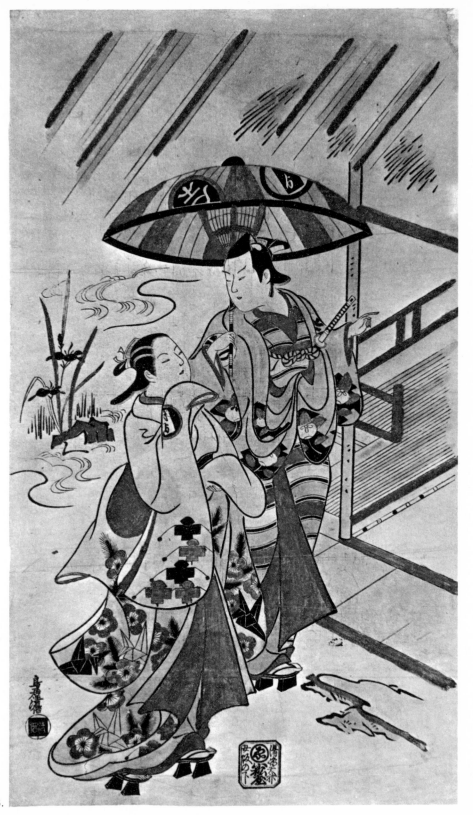

23.

17. The Courtesans Kazuma and Usugumo

From the illustrated book *Keisai Ehon (Album of Courtesans).*
Signature: *Yamoto gakō,* Torii Shōbei Kiyonobu *zu.* 1700.
Publisher: Shichirobei.
Double page, 10$\frac{1}{8}$ x 13$\frac{1}{2}$ inches.

The Art Institute of Chicago—Martin A. Ryerson Collection.

18. Tomisawa Hanzaburō and Yokoyama Rokurōji

From the illustrated book *Fūryu Shihō Byōbu (Refined Pleasure, Four Directions, Folding Screen).*
Signature: Torii Shōbei Kiyonobu *zu.* 1700.
Publisher: Shichirōbei.
Double page, 10$\frac{3}{4}$ x 13$\frac{1}{2}$ inches.

Museum of Fine Arts, Boston—Morse Collection.

19. The Actor Sawamura Kodenji as a Woman at the Time of the Tanabata Festival

Signature: *Yamato gakō* Torii Shōbei Kiyonobu *zu.* Seal: Kiyonobu. 1698.
Ink print with hand coloring, 20$\frac{7}{8}$ x 12$\frac{1}{8}$ inches.

Worcester Art Museum—The John Chandler Bancroft Collection.

Kodenji as Tsuyu no Mae performing a Kyōran (lunatic dance) before the Tadasu Shrine in the play "Kantō Koroku" which was produced at the Nakamura-za in 1698. Prints with a predominance of *tan,* a red-lead pigment, are called *tan-e.*

20. The Actor Uemura Kichisaburo as Nyosan no Miya

Signature: *Yamato gakō* Torii Shōbei. Seal: Kiyonobu. 1700.
Publisher: Shichirobei.
Ink print with hand coloring, 19 x 12$\frac{1}{4}$ inches.
Published: *The Clarence Buckingham Collection of Japanese Prints: The Primitives,* The Art Institute of Chicago, 1955, No. 10, p. 37.

The Art Institute of Chicago—Clarence Buckingham Collection.

The play, "Wakoku Gosuiden," with the "curtain raisers," "Nyosan no Miya Futatsu-Makura" and "Onna Chūshin Midari-bako," was performed at the Morita-za in 1700.

21. Painting a Screen

Signature: Kiyonobu. Seal: Kiyonobu. Seal at the right: Wakai. 1711; a companion print in the Shibui Collection bears this date.
Ink print with hand coloring, 10⅝ x 14⅝ inches.
Published: *The Clarence Buckingham Collection of Japanese Prints: The Primitives,* The Art Institute of Chicago, 1955, No. 21, p. 43.

The Art Institute of Chicago—Clarence Buckingham Collection.

22. A Dancer

Unsigned: attributed to Torii Kiyonobu. Late 1710's.
Ink print with hand coloring, 21¾ x 11½ inches.
Published: Louis V. Ledoux, *Japanese Prints of the Primitive Period in the Collection of Louis V. Ledoux,* 1942, No. 9.

The Metropolitan Museum of Art—Dick Fund, 1949.

23. The Actor Sanjō Kantarō II as Yaoya O-Shichi and Ichimura Takenojō as Kichisa

Signature: Torii Kiyonobu. Seal: Kiyomasu. 1718.
Publisher: Komatsuya.
Ink print with hand coloring, 26 x 19 inches.
Published: James A. Michener, *The Floating World,* 1954, No. 27, p. 298.

Museum of Fine Arts, Boston—James Fund.

The play "Nanakusa Fukuju Soga" was performed at the Ichimura-za in 1718. The story, concerning the lovely Yaoya O-Shichi and Kichisa, is one of the most popular love stories on the Edo stage. O-Shichi went with her parents to a temple for temporary abode while their house was being rebuilt after a great fire. While there, she fell in love

with a temple page named Kichisa. On returning home O-Shichi was unhappy without her lover, and set fire to their home in order to return to the temple. The fire she set started a great conflagration which burned a large part of the city. O-Shichi was seized and burned to death. Kichisa became a monk, spending the years praying for her pardon.

24. The Actor Ichikawa Kuzō as Miura Arajirō

Signature: Torii Kiyonobu *hitsu*. 1718.
Publisher: Emiya.
Ink print with hand coloring thickened and made glossy with glue, 11⅝ x 6 inches.
Published: James A. Michener, *Japanese Prints from the Early Masters to the Modern*, 1959, No. 31, p. 47.

From the Michener Collection, Honolulu Academy of Arts.

The play "Zen Kunen Yoroi-kurabe" was performed at the Morita-za in 1718. Many beautiful prints by the Torii artists are done in a technique called *urushi-e,* or lacquer picture. Here the black tone is thickened with glue to give brilliance and brass particles are added to colors for a sparkling effect in imitation of lacquerware.

清倍

TORII KIYOMASU I, worked 1696 to early 1720's

The problem regarding artists of the Torii School who bear the name Kiyomasu, has not been definitely solved. The late work, signed by Kiyonobu but bearing a Kiyomasu seal, may actually be the work of Kiyomasu, who was Kiyonobu's pupil; artists trained their successors, who often assumed the master's name and used it in signing prints. The artist under discussion we believe to be the first Kiyomasu, and the son or brother of Kiyonobu I with whom he studied. His *Plate 25* style is so close to that of Kiyonobu that it is often difficult to distinguish between *Plate 26* the unsigned works of the two artists. Kiyomasu illustrated books and albums, *Plates 27, 31* and designed courtesan and actor prints in large and small size. The prints of Kiyomasu more often have signatures than do those by Kiyonobu. This may be because of Kiyonobu's preoccupation with the painting of theatrical signboards and posters, probably an important task for the livelihood of the artist and his followers; as a consequence his prints were ferquently signed by his pupils.

Some of Kiyomasu's most distinguished compositions are seen in the black and white horizontal sheets designed for theatrical productions of 1715–1716 *Plate 28* and datable from playbills featuring the appearance of the great actor Danjuro II. Some two or three figures, well-related and drawn with a surety and beauty of line, are frequently shown. Kiyomasu's style is perhaps a little more subtle and graceful but lacks some of the exuberance of Kiyonobu's line. Kiyomasu's designs proudly proclaim him a great artist, whether in the large black and white prints or in those that have hand coloring, Kiyomasu's modification of the Kiyonobu line, portraying his ideal of serene beauty, influenced subsequent *Plates 29, 30* artists of the Torii School for years.

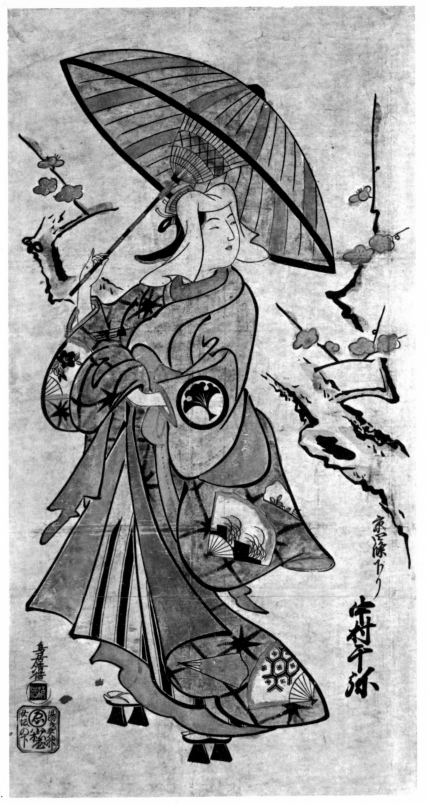

29.

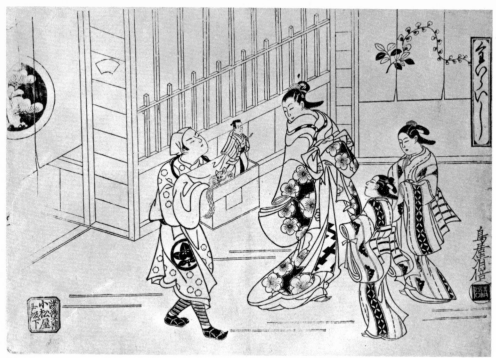

26.

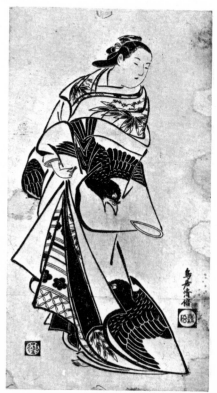

27.

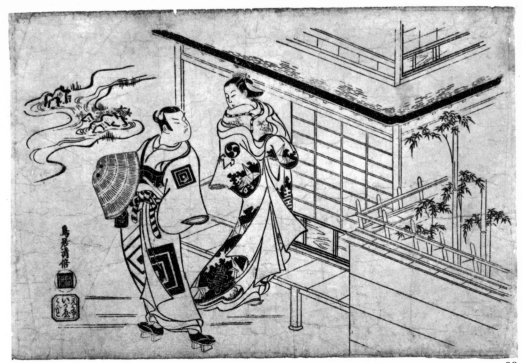

28.

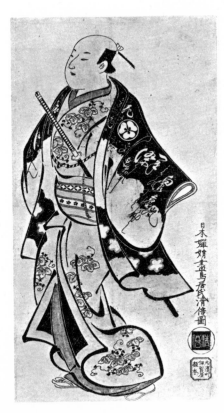

25.

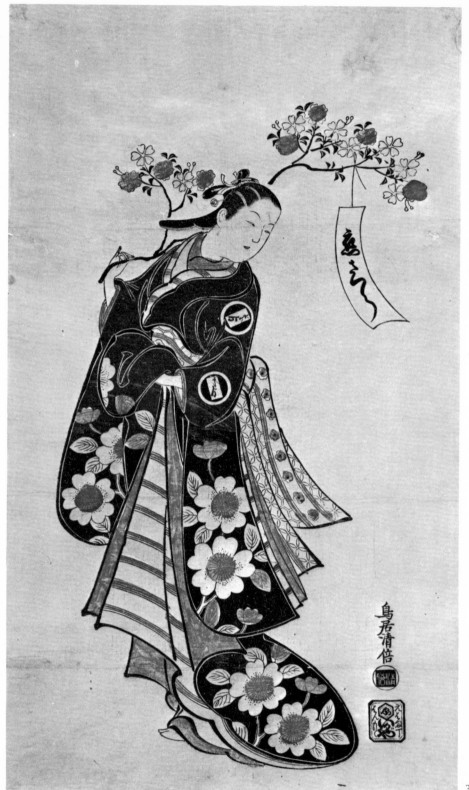

30.

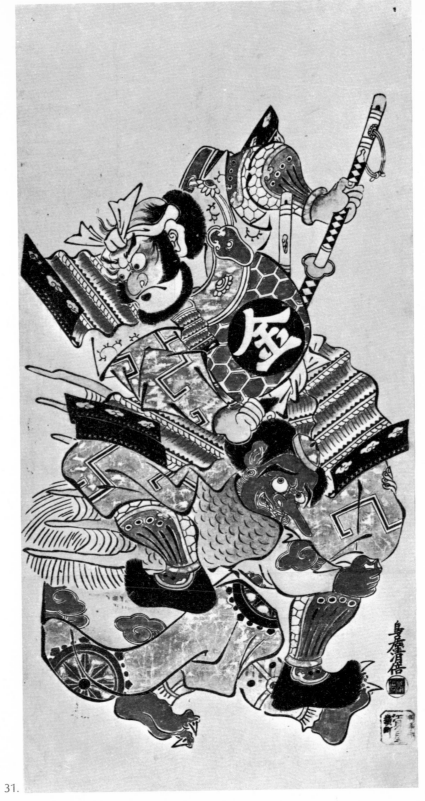

31.

25. Portrait of the Actor, Dekijima Shōgorō

Signature: *Nippon senkenga* Torii *shi* Kiyomasu *zu.* Seal: Kiyomasu. Mid-1710's.
Publisher: Igaya.
Ink print with hand coloring, 22³/₈ x 12¹/₄ inches.
Published: Vignier and Inada, *Estampes Japonaises Primitives,* 1909, Pl. XVII, No. 74.
The Clarence Buckingham Collection of Japanese Prints: The Primitives, The Art Institute of Chicago, 1955, No. 9, p. 52.

The Art Institute of Chicago—Clarence Buckingham Collection.

Shōgorō is dressed as a gay young man with his arms withdrawn inside the sleeves of the coat. The calligraphy lines are probably fragments of a popular song suggesting the storm at Yoshino scattering cherry blossoms like white waves.

26. A Courtesan and Attendants Watching a Puppet Performance

Signature: Torii Kiyomasu. Seal: Kiyomasu. Mid-1710's.
Publisher: Komatsuya.
Ink print, 11 x 16 inches.
Published: Louis V. Ledoux, *Japanese Prints of The Primitive Period in the Collection of Louis V. Ledoux,* 1942, No. 10.

The Metropolitan Museum of Art—Dick Fund, 1949.

The actor Ichimura Takenojō VII as a showman manipulating puppets of a man and a fox. The narrow sign at the far right reads: Street of Puppet Showman.

27. Beauty Looking toward the Left

Signature: Torii Kiyomasu. Seal: Kiyomasu. Mid-1710's.
Publisher: Nakajimaya.
Ink print, 22³/₄ x 12¹/₂ inches.
Published: Robert Treat Paine and Alexander Soper, *The Art and Architecture of Japan,* 1955, p. 111. *The Clarence Buckingham Collection of Japanese Prints: The Primitives,* The Art Institute of Chicago, 1955, No. 4, p. 49.

The Art Institute of Chicago—Clarence Buckingham Collection.

28. Ichikawa Danjūrō II as Soga no Gorō and Nakamura Takesaburō as Kewaizaka no Shōsho

Signature: Torii Kiyomasu. Seal: Kiyomasu. 1715.
Publisher: Igaya.
Ink print, 12 x 17³/₈ inches.
Published: *The Clarence Buckingham Collection of Japanese Prints: The Primitives,* The
Art Institute of Chicago, 1955, No. 11, p. 53.

The Art Institute of Chicago—Clarence Buckingham Collection.

Danjūrō II is dressed in the garb of a mendicant *komusō* priest. The play, "Bando-ichi
Kotobuki Soga" was performed at Nakamura-za in 1715.

29. The Actor Nakamura Senja Walking near a Plum Tree

Signature: Torii Kiyomasu. Seal: Kiyomasu. 1716.
Publisher: Komatsuya.
Ink print with hand coloring, 23¹/₄ x 12¹/₄ inches.
Published: Louis V. Ledoux, *Japanese Prints of the Primitive Period in the Collection of
Louis V. Ledoux,* 1942, No. 13.

The Metropolitan Museum of Art—Dick Fund, 1949.

The inscription at the right gives the actor's name and states that he is to come from
Kyoto for performances. The play, "Mitsu Tomoe Katoku binaki," was given at the
Nakamura-za toward the end of 1716.

30. An Actor as Yaoya O-Shichi

Signature: Torii Kiyomasu. Seal: Kiyomasu. Late 1710's.
Publisher: Igaya.
Ink print with hand coloring, 21¹/₂ x 12³/₄ inches.

Museum of Fine Arts, Boston—James Fund.

The play has not been identified. From the cherry branch hanging over the actor's shoul-
der, hangs a *tanzaku* (paper on which odes are inscribed) reading *Koi-zakura* "love
cherry."

31. Sakata no Kintoki Capturing a Tengu

Signature: Torii Kiyomasu. Seal: Kiyomasu. Late 1710's.
Publisher: Emiya.
Ink print with hand coloring, 26¾ x 13 inches.
Published: *The Clarence Buckingham Collection of Japanese Prints: The Primitives,* The Art Institute of Chicago, 1955, No. 3, p. 48.

The Art Institute of Chicago—Clarence Buckingham Collection.

The story of Kintoki, the fabulous strong boy of the mountains, and Minamoto no Yorimitsu is a favorite legend in Japan. Later in life Kintoki became one of the personal body-guards of Minamoto no Yorimitsu and shared in his exploits against goblins, monsters and ogres which appear to have been very numerous around Kyoto in the eleventh century. He is shown here in full armor, with the character "Kin" for Kintoki on his corselet. A *tengu* is a winged goblin with human face, a very long nose, and webbed feet, who lived on Mount Kurama and is peculiar to Japan.

THE KAIGETSUDO, worked 1700—1720

Shortly before the year 1714 a group of prints was issued, during a brief period, by three of the four or five pupils of Ando Kaigetsudō, a painter who never designed prints. Their theme, like Ando's, was the fashionable picture of the popular courtesans of the Yoshiwara. These artists' mannerisms were so nearly *Plates 32, 34, 37* identical that their work was often thought by European scholars to be the work of a single printmaker. However, Japanese scholars easily perceived differences in the designs and calligraphic signatures of these artists even though they looked so alike to Western eyes. Ando was a tremendous success as a painter of courtesans until his involvement in an affair between the Lady Ejima and a handsome Kabuki actor. When this affair came to the notice of the authorities all the participants were banished from Edo, and Ando had to forsake his career upon his exile to the island of Ōshima.

Stylistically, the Kaigetsudō artists employed something of the technique of the Torii School, with their specialization in signboards and actor prints calling *Plate 35* for the use of a wide, carrying stroke and strong flat colors. The artists who designed these prints were Anchi, Doshin and Dohan. Preceding their signatures, we find the inscription "follower of Kaigetsudō" asserting their allegiance to Ando. These large upright prints are extremely rare; only thirty-nine existing impressions of twenty-two different designs are known. Probably only twenty-four of these designs were executed in all, between the years 1712 and 1714. Their vision is powerful and imposing in the representation of a towering single *Plate 33* figure of a standing courtesan dressed in flowing robes. The feeling of movement is intense as the brush strokes build an effective structure to house the *Plate 36* elegant figure under the elaborate swirl of the kimono. The Kaigetsudō created a strong symbol of the idealized woman—tall, stately, and austere—whose beauty appealed to the connoisseurs of Edo, and who in their solitary splendor still *Plate 38* appeal to us.

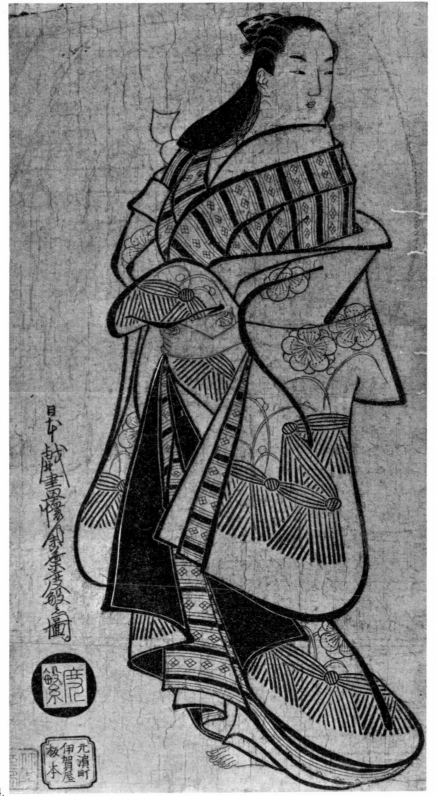

34.

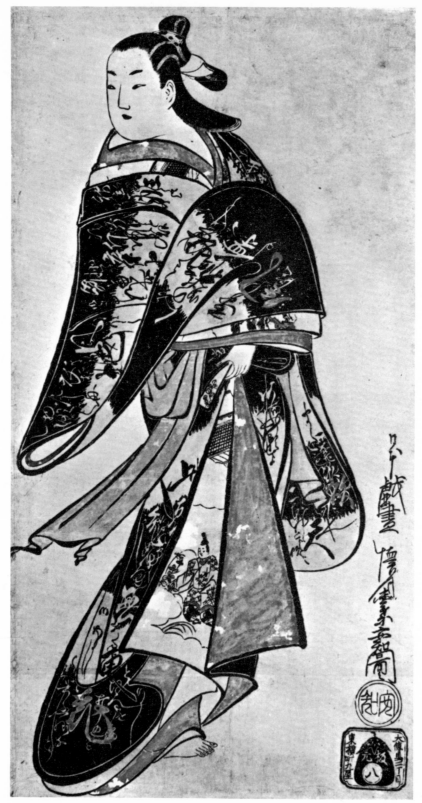

32.

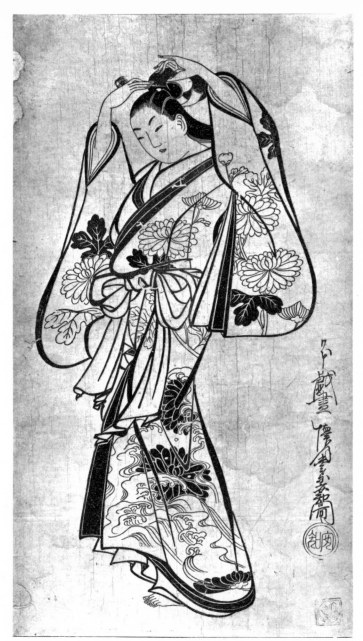

33.

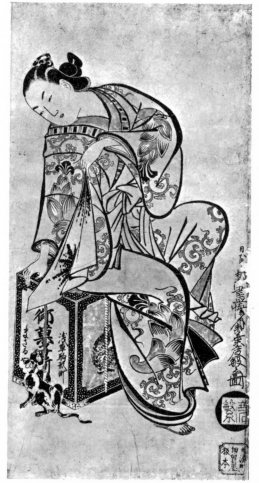

35.

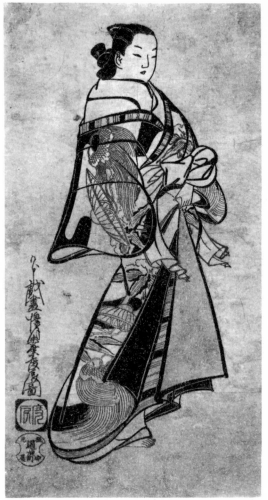

37.

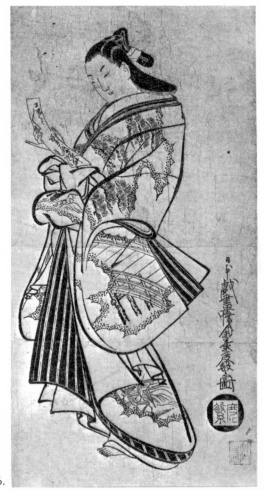

36.

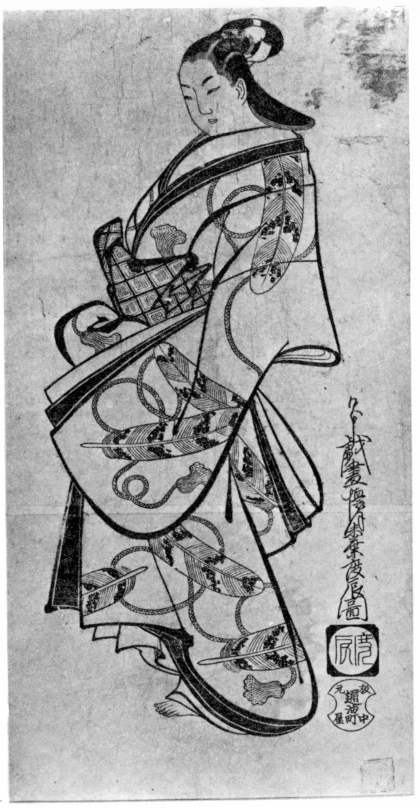

38.

32. Beauty Looking over her Right Shoulder

Signature: *Nippon giga* Kaigetsu *matsuyō* Anchi *zu.* Seal: Anchi. Mid-1710's.
Ink print with hand coloring, 21¾ x 11½ inches.
Publisher: Maruya.
Published: *The Clarence Buckingham Collection of Japanese Prints: The Primitives,* The
Art Institute of Chicago, 1955, No. 2, p. 24.

The Art Institute of Chicago—Clarence Buckingham Collection.

33. Beauty Placing an Ornamental Hairpin

Signature: *Nippon giga* Kaigetsu *matsuyō* Anchi *zu.* Seal: Anchi. Collector's seal at lower
right: Takeuchi. Mid-1710's.
Ink print, 22¾ x 12¾ inches.
Published: Arthur Davison Ficke, "The Prints of Kwaigetsudō". *The Arts,* Vol. IV, No. 2,
1923, p. 111. Louis V. Ledoux, *An Essay on Japanese Prints.* The Japan Society, 1938, Pl. 1.
Louis V. Ledoux, *Japanese Prints of the Primitive Period in the Collection of Louis V.
Ledoux,* 1942, No. 19.

The Metropolitan Museum of Art—Dick Fund, 1949.

There is no other recorded impression of this print.

34. Beauty Looking over her Shoulder

Signature: *Nippon giga* Kaigetsu *matsuyō* Dohan *zu.* Seal: Dohan. Collector's seal at far
left corner: Takeuchi *zo in.* Mid-1710's.
Publisher: Igaya.
Ink print, 22¼ x 12 inches.
Published: Arthur Davison Ficke, "The Prints of Kwaigetsudō." *The Arts,* Vol. IV, No. 2,
1923, p. 106. Louis V. Ledoux, *Japanese Prints of the Primitive Period in the collection of
Louis V. Ledoux,* 1942, No. 15.

The Metropolitan Museum of Art—Dick Fund, 1949.

There is no other recorded impression of this print. The faint mark showing across the
center of the print was made when it was folded for keeping in a portfolio where Mon-
sieur Raymond Koechlin found it long ago in a small bookstall beside the Seine.

35. Beauty Playing with a Cat

Signature: *Nippon giga* Kaigetsudō *matsuyō* Dohan zu. Seal: Dohan. Late 1710's.
Publisher: Igaya.
Ink print with hand coloring, 22½ x 11½ inches.
Published: Vignier and Inada, *Estampes Japonaises Primitives,* 1909 Pl. VII, No. 24. *The Clarence Buckingham Collection of Japanese Prints: The Primitives,* The Art Institute of Chicago, 1955, No. 1, p. 25.

The Art Institute of Chicago—Clarence Buckingham Collection.

The courtesan is seated on a large box of confections labeled: House of Masaru, seller of confections in Komagata Street, Asakusa.

36. Courtesan Holding a Poem Slip

Signature: *Nippon giga* Kaigetsū *matsuyō* Dohan *zu.* Seal: Dohan. Collector's seal at lower right corner: Takeuchi *zo in.* Late 1710's.
Ink print, 23½ x 12½ inches.
Published: Louis V. Ledoux, *Japanese Prints of the Primitive Period in the Collection of Louis V. Ledoux,* 1942, No. 17.

The Metropolitan Museum of Art—Dick Fund, 1949.

According to Louis V. Ledoux the characters that can be seen inscribed on the poem slip are roughly translated (with three final words added to give the meaning which is only implied on the original): "Morning and evening I part my dishevelled hair as one would part rice sprouts, wondering when, when will he come."

37. Courtesan Walking to the Right

Signature: *Nippon giga* Kaigetsū *matsuyō* Doshin *zu.* Seal: Doshin. Late 1710's.
Publisher: Nakaya.
Ink print with hand coloring, 12³⁄₈ x 23 inches.
Published: Edwin Grabhorn, *Figure Prints of Old Japan.* Printed for the Book Club of California, 1959, No. 6.

Edwin Grabhorn Collection, San Francisco.

38. Courtesan Walking to the Left

Signature: *Nippon giga* Kaigetsū *matsuyō* Doshin *zu*. Seal: Doshin. Collector's seal at lower right corner: Takeuchi *zo in*. Late 1710's.
Publisher: Nakaya.
Ink print, 23½ x 12½ inches.
Published: Louis V. Ledoux, *Japanese Prints of the Primitive Period in the Collection of Louis V. Ledoux,* 1942, No. 18.

The Metropolitan Museum of Art—Dick Fund, 1949.

奥村政信

OKUMURA MASANOBU, 1686—1764

Masanobu's artistic life spans almost the whole range of the early period of *Ukiyo-e*, beginning with his forceful black and white prints, the larger prints with strong hand coloring, and the lacquer prints. Its close is marked by the two-color prints which were made just before the invention of full color printing. Masanobu is thought to have been self-taught but his earliest dated work shows the influence of Kiyonobu and something of the style of Moronobu. Masanobu's wit and the characteristics of his own talent are soon evident in the numerous series of black and white picture albums produced in the early eighteenth *Plate 42* century. Scenes of the Yoshiwara, of the Kabuki and puppet theaters, and historic legends and parodies on classic themes are all treated by Masanobu in a modern manner. The people of Edo could enjoy and appreciate the literary *Plate 40* allusions and humor of Masanobu's designs as well as the beauty and verve of his line. Throughout his life Masanobu produced picture books and illustrated novels and eventually established a publishing house to produce his own work.

Plate 41 The large size, hand colored prints of "beauties" are equal in vigor and dignity to the work of his famous contemporaries, the Torii and the Kaigetsudō, and are more lively and not so aloof in conception as those of the latter artists. With changing fashions and styles Masanobu became the leader in producing a new type of print called *urushi-e* or "lacquer picture". He used a wide range of sub-*Plate 43* ject matter in creating in this new medium and, though small in size, the prints

are beautifully designed and composed. After Masanobu began publishing his own prints, he claimed to have founded one style of *Ukiyo-e* print and some authorities do ascribe the invention of both the lacquer and pillar print to him. *Plate 44* Certainly Masanobu experimented in many styles and when the fashion of larger prints came again into vogue around 1740, we find him designing excellent pictures with perspective backgrounds in Western style. He was ahead of *Plate 45* the field with tall panel pictures of the most popular Kabuki actors as well as *Plate 46* with portrayals of courtesans of the day. These are distinguished by their beauty of line and their surpassing grace, and were hand colored in a wide range of warm hues. Around this period, the important invention of printing with two colors was developed and Masanobu experimented in this field with great success. The two colors, rose-red and green, were a most happy choice and with the lesser areas of black produced a striking color scheme. Masanobu designed and published some of the loveliest prints in this field. *Plates 47, 48*

As a very gifted artist in tune with the times, he obligingly created for a public always in search of something new. Masanobu has left us many pictures of the floating and fleeting world of *Ukiyo-e,* in which he was so inventive, but only one picture that might be a self-portrait. Here, wearing glasses, moustache, *Plate 39* chinwhiskers and beret, Masanobu sits on his haunches signing his name to a screen. As anyone can see, he is an artist of importance, sure of himself and his talent, and time has proven that he did not underestimate himself.

47. Okumura Masanobu. *Burning Maple Leaves to Heat Sake*. Early 1750's.

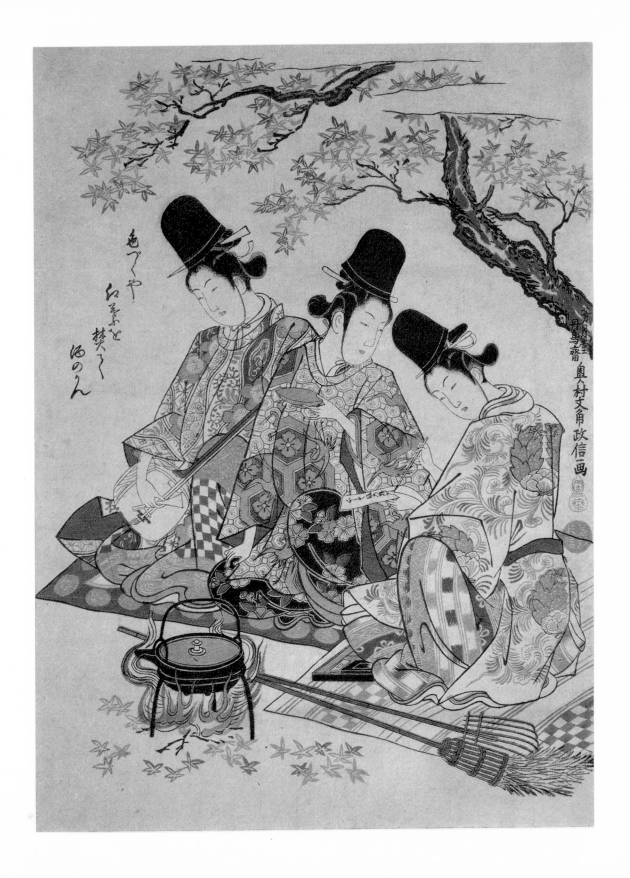

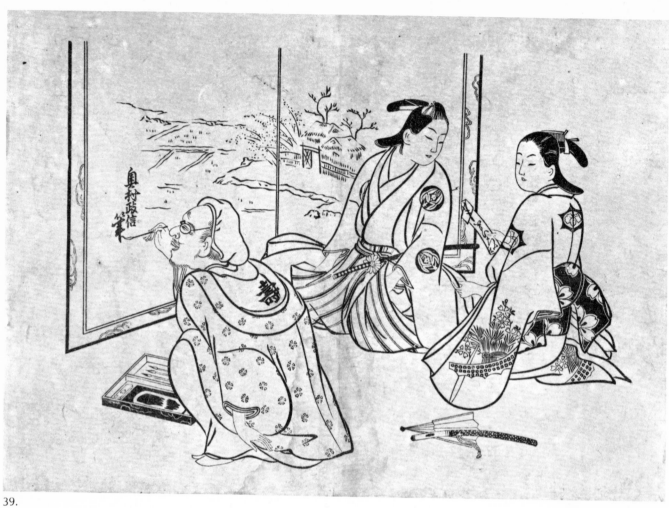

39.

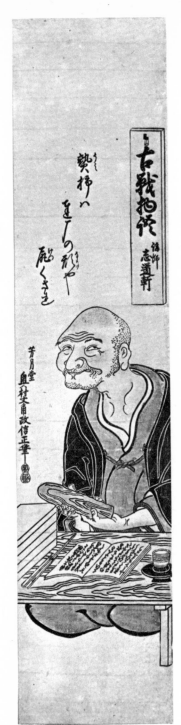

44.

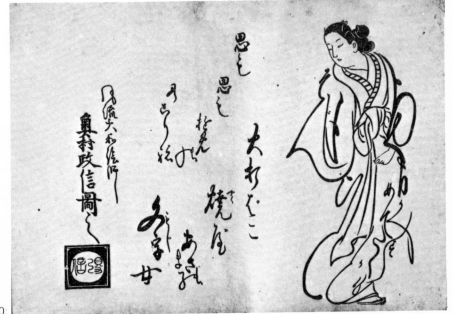

40.

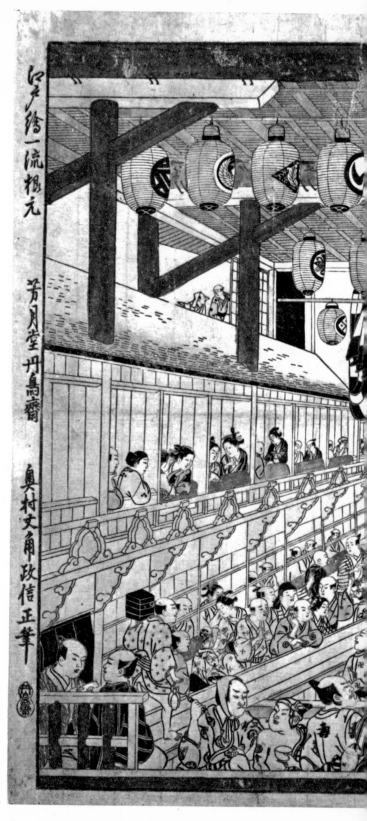

45.

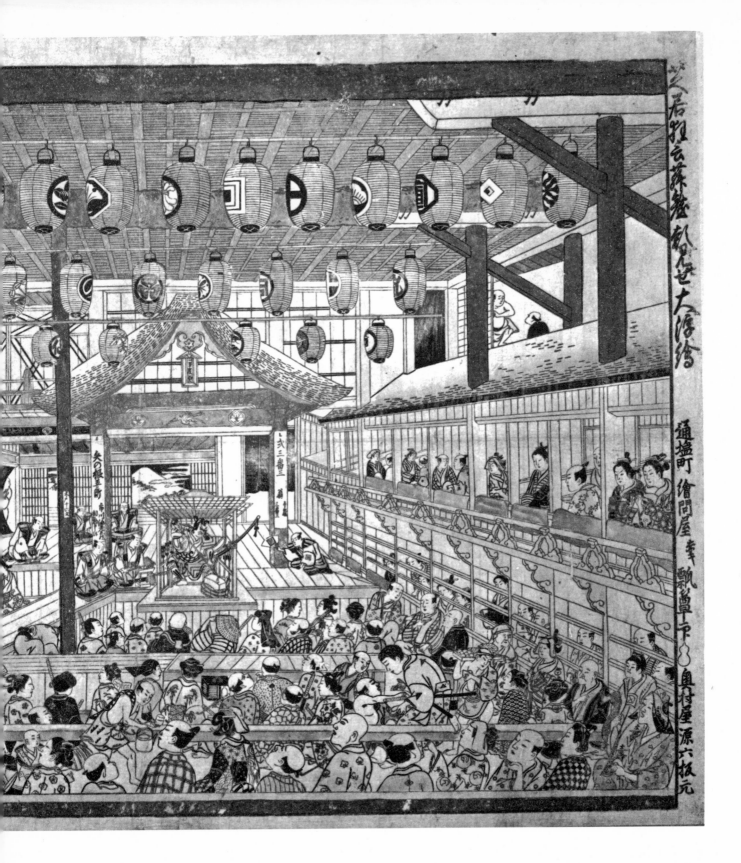

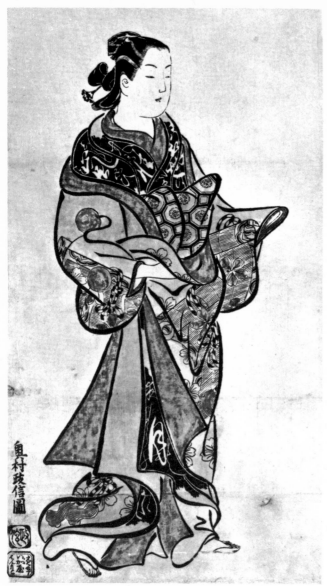

41.

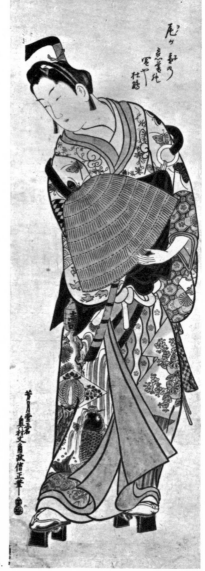

46.

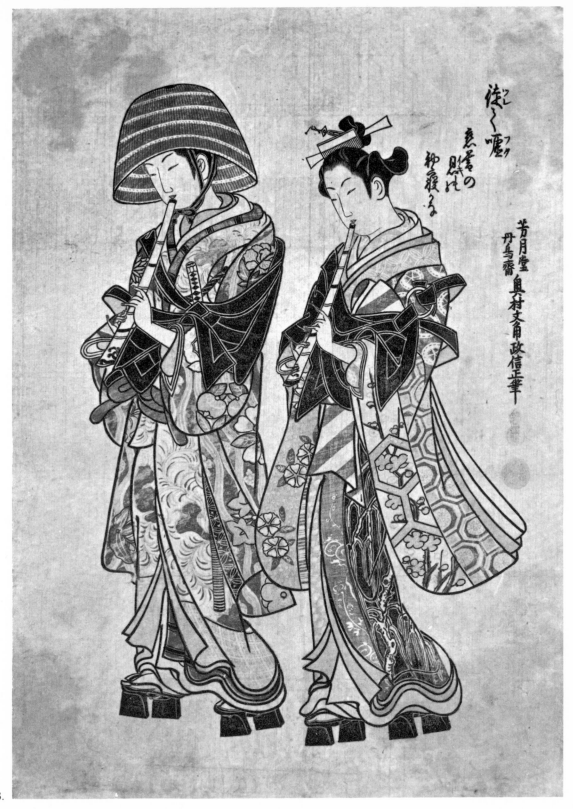

48.

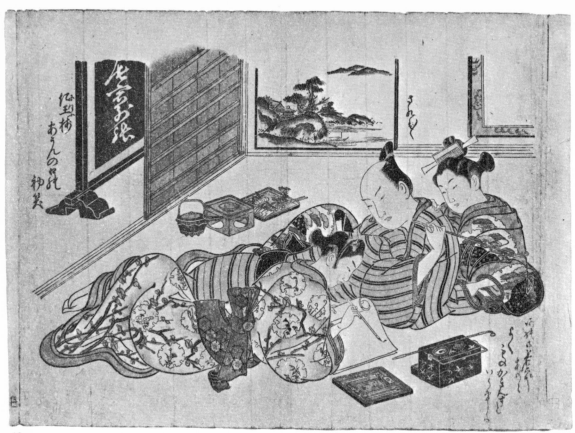

42.

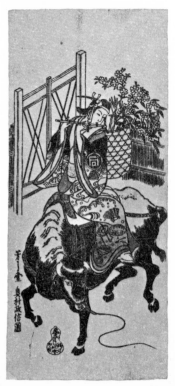

43.

39. An Artist Writing upon a Screen

Signature: Okumura Masanobu *hitsu.* Circa 1710's.
Ink print, 10½ x 15 inches.

The Art Institute of Chicago—Clarence Buckingham Collection.

This is the first sheet from an album of twelve on *ukiyo*-e travesties. Lovers are seated beside a screen on which the artist, probably Masanobu, signs his name. This is a second edition. In the first, a long inscription on the screen states that Masanobu was requested to make some drawings of classical subjects but to treat them in a modern *ukiyo*-e way. The drawings were so good they were engraved on wood for publication.

40. A Courtesan

Signature: *Fūryū Yamato eshi* Okumura Masanobu *kore wo zu su.* Seal: Masanobu. Mid-1710's.
Ink print, 14½ x 10⅝ inches.
Published: *The Clarence Buckingham Collection of Japanese Prints: The Primitives,* The Art Institute of Chicago, 1955, No. 55, p. 136.

The Art Institute of Chicago—Clarence Buckingham Collection.

The outline of the courtesan's figure is composed of phrases used by women in letter writing. The poem reads, "Think and think of the remnant of a dream."

41. Courtesan Walking to the Right

Signature: Okumura Masanobu *zu.* Seal: Masanobu. Mid-1710's.
Publisher: Igaya.
Ink print with hand coloring, 21⅛ x 11½ inches.
Published: *The Clarence Buckingham Collection of Japanese Prints: The Primitives,* The Art Institute of Chicago, 1955, No. 59, p. 139.

The Art Institute of Chicago—Clarence Buckingham Collection.

Her outer robe is decorated with bamboo curtains and her kimono with calligraphy, probably phrases of a song, "Storm expectations and the whole night of the moon."

42. Entertaining the Lovers

From the album entitled *Hill of Dyed Color Specimens of Bedrooms*. Unsigned: Only last sheet of the series is signed Masanobu. Late 1730's.
Ink print with hand coloring, 10³/₄ x 15¹/₈ inches.
Published: Louis V. Ledoux, *Japanese Prints of the Primitive Period in the Collection of Louis V. Ledoux,* 1942, No. 23.

The Brooklyn Museum.

The lovers are reclining on the floor as they watch an effeminate young man about to write a letter. Near the smoking set is a hand written inscription; one done with a light brush as though whispered reads: "I say, young master, what about...I mean." The second is written in a heavier script as though spoken aloud for the youth to hear: "I said how beautifully you write." Near the landscape on the rear wall is written, "Well then. Well then." Outside the room at the left is written an ode: "The fragrant plum first laughs on the open and closed months."

43. The Actor Ichimatsu I as a Herdsman

Signature: Hōgetsudō Okumura Masanobu *zu.* 1741.
Publisher: Okumuraya.
Ink print with hand coloring thickened and made glossy with glue and brass particles, 12³/₄ x 5³/₄ inches.
Published: *The Clarence Buckingham Collection of Japanese Prints: The Primitives,* The Art Institute of Chicago, 1955, No. 87, p. 159.

The Art Institute of Chicago—Clarence Buckingham Collection.

44. Portrait of Shidōken the Storyteller

Signature: Hōgetsudō Okumura Bunkaku Masanobu *shōhitsu.* Seal: Tanchōsai. Early 1740's.
Ink print with hand coloring, 27³/₈ x 6¹/₈ inches.

Published: *The Clarence Buckingham Collection of Japanese Prints: The Primitives,* The Art Institute of Chicago, 1955, No. 91, p. 159.

The Art Institute of Chicago—Clarence Buckingham Collection.

The tablet over the head of Shidōken reads: "Tales of Ancient Battles (by) Lecturer Shidōken." The ode at the side reads: "The over-ripe persimmon is shaped like Daruma: its bottom rotten." On the table before Shidōken lies an open volume of Tsurezure-gusa. He holds in his hands a large wooden emblem of phallic significance used to emphasize the obscenities in his boisterous tales.

Shidōken as a youth entered a monastery to study for the Buddhist priesthood. His ability to learn and expound the scriptures impressed his superiors. They placed him in charge of the novices. However, his conduct was so immoral that he was expelled. After several years Shidōken reached Edo and finally set up his stall near the Kannon Temple in Asakusa Park. With his marvelous gifts of mimicry Shidōken became an idol of the Edo populace who crowded his booth to buy love potions and horoscopes and to hear his famous tales.

45. Large Perspective Picture of the Kaomise Performance of Drama and Comedy

Signature: Hōgetsudō Tanchōsai Okumura Bunkaku Masanobu *shōhitsu.* Seal: Tanchōsai.
1740.
Publisher: Okumuraya.
Ink print with hand coloring, 18¼ x 26¾ inches.
Published: *The Clarence Buckingham Collection of Japanese Prints: The Primitives,* The Art Institute of Chicago, 1955, No. 83, p. 154.

The Art Institute of Chicago—Clarence Buckingham Collection.

Masanobu has pictured the impersonation of Ichikawa Ebizō as Yanone Gorō in the play "Miyabashira Taiheiki" performed at the Nakamura-za in 1740. The stage still has the form of a Shintō shrine associated in our minds with the Nō stage of today. We see here the various types of Edo citizens who attend the Kabuki plays. The large windows in the upper story are to give as much light as possible, the lanterns bearing actors' crests are strung across the roof, and the performances of the day are announced on the pillars at the side of the stage. Over the stage is a Shintō tablet of purification and on the pillar in the center of the theater is the announcement: "Price of admission 16 mon."

46. Onoe Kikugorō I As Soga no Gorō

Signature: Hōgetsudō Shōmei Okumura Bunkaku Masanobu *shōhitsu*. Seal: Tanchōsai. 1744.
Ink print with hand coloring, 25³/₄ x 8⁷/₈ inches.
Published: *The Clarence Buckingham Collection of Japanese Prints: The Primitives,* The Art Institute of Chicago, 1955, No. 95, p. 160.

The Art Institute of Chicago—Clarence Buckingham Collection.

The famous actor plays the role of Soga no Gorō disguised as a mendicant priest at the Ichimura-za in 1744. A poem at the top of the print reads "In the darkness of love, with his own voice, the cuckoo" (a pun on "own" and "onoe"). On his *inro* hanging from his belt appears the character, *Ju,* "long life."

47. Burning Maple Leaves to Heat Sake

Signature: Hōgetsudō Tanchōsai Okumura Bunkaku Masanobu ga. Seals: Tanchōsai and Okumura Masanobu. Early 1750's.
Two-color print, 16¹/₄ x 12 inches.
Published: Louis V. Ledoux, *Japanese Prints of the Primitive Period in the Collection of Louis V. Ledoux,* 1942, No. 26.

The Metropolitan Museum of Art—Dick Fund, 1949.

Three girls in the costume of guards of the palace are seated under a maple tree heating sake over a fire. One plays the samisen, another holds a sake cup while the third is writing on a poem slip. The poem from which the opening lines are taken is by Lady Shimotsuke: "mindful of what the wind has left." At the left is a complete poem: "More brilliant grow the colors of maple leaves burning under sake kettles."

48. Strolling Musicians

Signature: Hōgetsudō Tanchōsai Okumura Bunkaku Masanobu *shōhitsu*. Seal: Tanchōsai. Early 1750's.
Two-color print, 17³/₈ x 12¹/₄ inches.

Worcester Art Museum—The John Chandler Bancroft Collection.

The lovers are masquerading as mendicant priests playing the flute and the youth wears the traditional basket hat.

春信

春
信

HARUNOBU, C 1725—1770

In the field of Japanese prints, Harunobu's designs probably exert the greatest charm for the largest number of people. As is often the case with the *ukiyo*-e artists, very little is known about his life. The prevalent opinion is that he was born in Edo and lived there until his death at the age of forty-five. Although Harunobu is said to have been a pupil of Nishimura Shigenaga, his early work printed in two, or occasionally three, colors, shows his dependency on Kiyomitsu, the leader of the Torii School at the time. He not only copied the style of Kiyomitsu, but also used the subject matter of Sukenobu's illustrated books. The few extant prints from this period give no evidence of the artist he was to become.

Some time during the year 1764, when technical improvements were made in the art of engraving and printing, a device was discovered to give accuracy of register to impressions taken from an increased number of color blocks. Haru-nobu had received a special commission to design pictorial calendars for a group of aesthetes for the year 1765. Having by now developed a style quite distinctly his own, Harunobu conceived the idea of printing with many soft opaque colors in a new, almost square format on the finest of papers to satisfy his patrons'

extravagant tastes. Working closely with the block cutter and printer, Harunobu produced the full color print known as *nishiki-e* "brocade picture", so-called because of the variety of colors. The importance of this achievement was quickly recognized and for the first time the names of the two artisans were placed beside that of the artist on the face of the print, as seen in Plate 49 where the artisans' signatures appear after the artist's.

Plate 50

Harunobu took full advantage of this new technique to create a fragile world of youth and beauty, untouched by the reality of life. It was a world of lovely young girls at their daily occupations, lovers playing a musical instrument together or walking in the snow. His subjects are placed in a variety of backgrounds which range all the way from a solid, light pearl-grey to charming landscapes and complicated intercrossed lines depicting vistas of open rooms and verandas. In the serenity and charm of his compositions Harunobu is unsurpassed, his line is firm and of great charm and his prints have a grace and sweetness that are all their own. No trace of the statuesque beauties of the earlier period remains, for Harunobu turned the mirror on his audience and pictures for us the wives and daughters of the merchant class.

Plate 50

Plates 54, 55

Plate 52

Plate 53

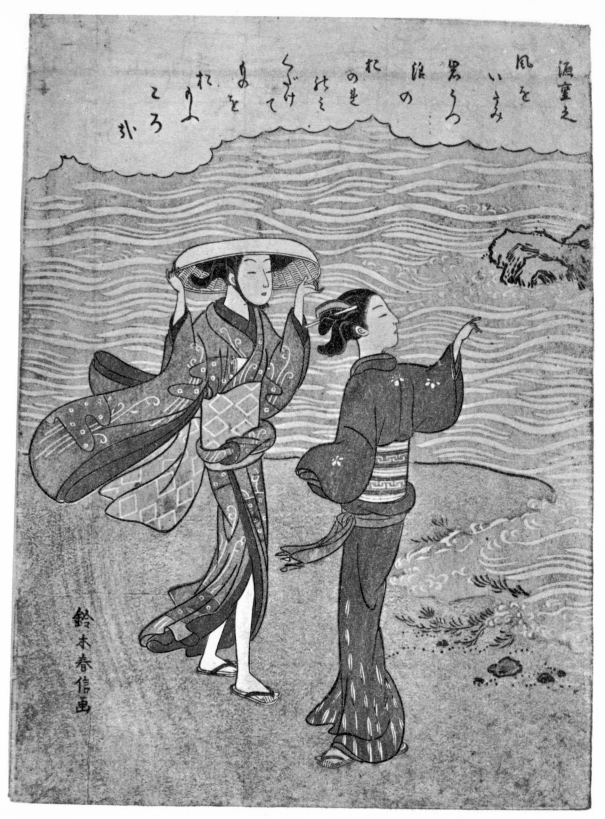

53.

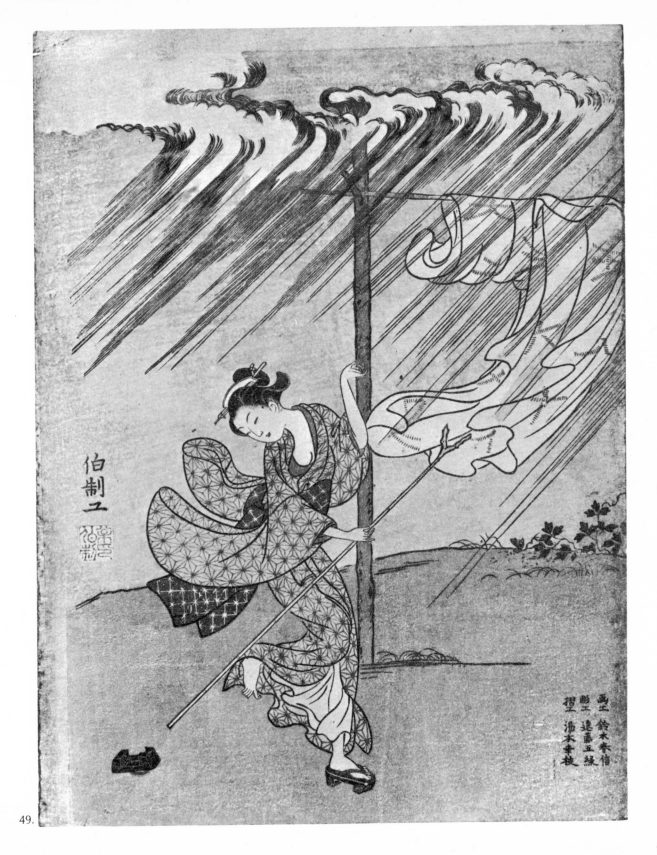

49.

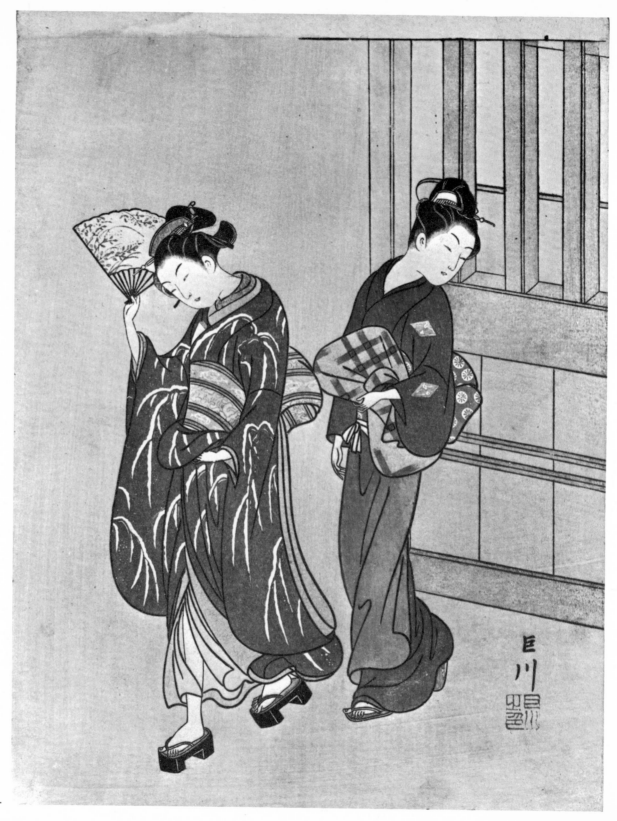

51.

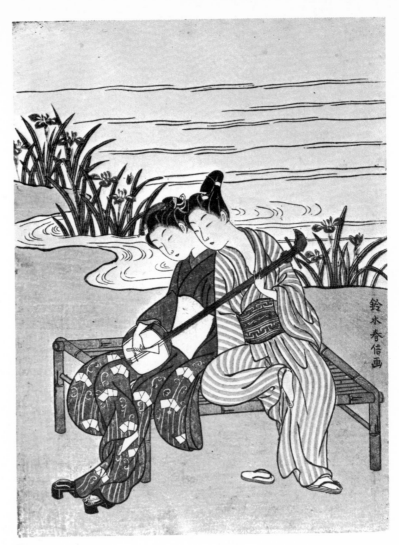

54.

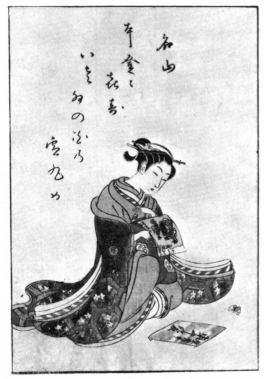

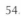

56.

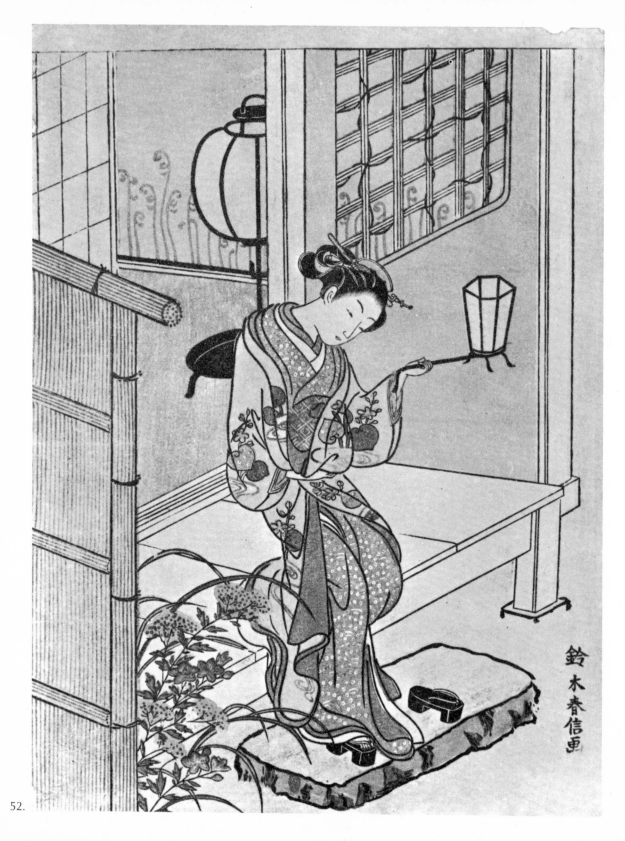

52.

鈴木春信画

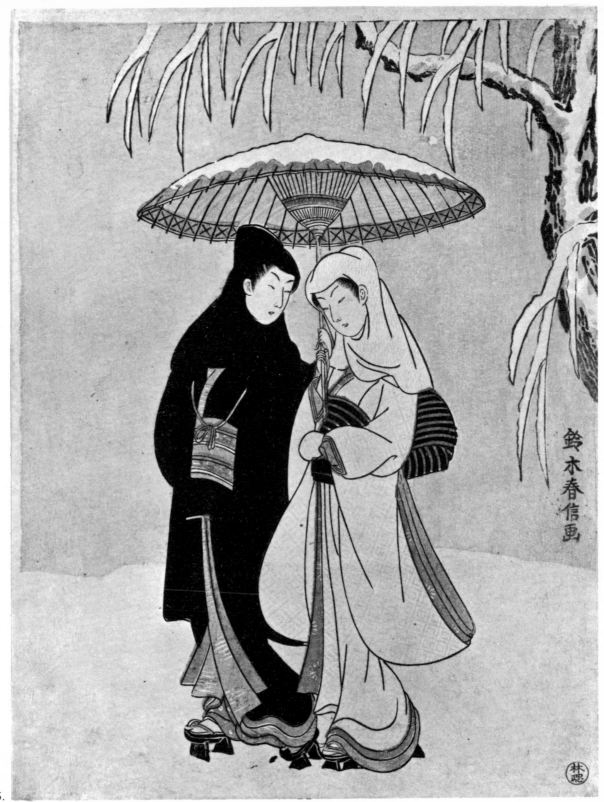

鈴木春信画

55.

49. A Young Girl in a Summer Shower

Signatures at lower right: *gakō* (painter) Suzuki Harunobu; *chōkō* (engraver) Endō Go-ryoku, *surikō* (printer Yumoto Sachie (Kōshi).
Signature and seal at left: Haku Seikō (designer); Seal: Shokoku sei in. 1765.
Polychrome print, 11¼ x 8⅝ inches.
Published: *Japanese Prints: A Selection from the Charles J. Morse and Jared ·K. Morse Collection.* Wadsworth Atheneum, 1951, Pl. IX, No. 47. *The Clarence Buckingham Collection of Japanese Prints: Harunobu, Koryusai, Shigemasa, Their Followers and Contemporaries,* The Art Institute of Chicago, 1964, No. 24, p. 12.

The Art Institute of Chicago—Clarence Buckingham Collection.

Around the year 1765 there had emerged in Edo numbers of dilettante poets who formed themselves into groups to enjoy various aesthetic pursuits. The members held meetings where they exchanged privately issued prints and calendar prints in which the numerals for the long and short months were cleverly interwoven in the designs. Here they appear in the robe flying from the bamboo pole. Sometimes the calendar prints were drawn by the member who conceived the idea, but the majority were executed by commissioned artists, among whom Harunobu seems to have been the leader. On many of these prints the artist's name is omitted but the name of the man who had commissioned the print is given followed by the character *ko* used in the sense of conceived by or originated by.

50. The Descending Geese of the Koto Bridges

From the series entitled "Eight Parlor Views"
Signature: Kyosen. Seals: Sōsei Sanjin and Kyosen no in. 1766.
Polychrome print, 11⅜ x 8½ inches.
Published: *The Clarence Buckingham Collection of Japanese Prints: Harunobu, Koryūsai, Shigemasa, Their Followers and Contemporaries,* The Art Institute of Chicago, 1964, No. 56, p. 35.

The Art Institute of Chicago—Clarence Buckingham Collection.

This and the following print (51) are from the earliest printing of the famous series representing indoor scenes reminiscent of the subjects used in the "Eight Views" of landscape originally done in China in the Sung Dynasty. Japanese paintings and prints feature eight views of Lake Biwa, which are known as "Ōmi Hakkei." Here the artist whimsically suggests a subject used in that series; the fixtures known as bridges which support the strings of the musical instrument, the *Koto,* are a visual pun suggesting the descending flight of wild geese. The full series in the Buckingham Collection was purchased by Alexander Mosle in Japan as being the personal set owned by the poet Kikurensha

Kyosen, who is said to have commissioned Harunobu to make the designs. A second state of these prints has the Kyosen signature and seal removed and still later editions have the artist's name, Suzuku Harunobu or Harunobu, added.

51. Clearing Weather of the Fan

Series, signature and date are the same as Plate 50.
Polychrome print, 11¼ x 8½ inches.
Published: *The Clarence Buckingham Collection of Japanese Prints: Harunobu, Koryusai, Shigemasa, Their Followers and Contemporaries.* The Art Institute of Chicago, 1964, No. 59, p. 39.

The Art Institute of Chicago—Clarence Buckingham Collection.

Kikurensha Kyosen, a samurai and poet, became the moving spirit in his particular circle of art lovers which came to be known as Kyosen-*ren* or "Kyosen group." They held meetings where they exchanged these privately issued prints or pictorial calendars. Here the fan, about to stir the air, symbolizes clearing weather.

52. Girl with Hand Lantern

Signature: Suzuku Harunobu *ga.* Late 1760's.
Polychrome print, 11¼ x 8³/₈ inches.
Published: *The Clarence Buckingham Collection of Japanese Prints: Harunobu, Koryusai, Shigemasa, Their Followers and Contemporaries.* The Art Institute of Chicago, 1964, No. 140, p. 85.

The Art Institute of Chicago—Clarence Buckingham Collection.

53. A Breezy Day by the Sea

Signature: Suzuku Harunobu *ga.* Late 1760's.
Polychrome print, 11³/₈ x 8³/₈ inches.
Published: Louis V. Ledoux, *Japanese Prints by Harunobu and Shunshō in the Collection of Louis V. Ledoux,* 1945, No. 23.

Mr. and Mrs. Richard P. Gale, Mound, Minnesota.

The two women stand in the strong wind while one points to the waves breaking against the nearby rock. On the cloud above is a poem of the tenth century by Minamoto no Shigejuki: "As waves, wind driven, break over the rock, so I alone suffer from a breaking heart these days."

54. Lovers Playing the Samisen

Signature: Suzuki Harunobu *ga*. Late 1760's.
Polychrome print, 10½ x 7¾ inches.
Published: Louis V. Ledoux, *Japanese Prints by Harunobu and Shunshō in the Collection of Louis V. Ledoux*, 1945, No. 13.

Mr. and Mrs. Richard P. Gale, Mound, Minnesota.

55. Lovers

Signature: Suzuki Harunobu *ga*. Seal at lower right: Hayashi. Late 1760's.
Polychrome print, 10¼ x 7¾ inches.
Published: Louis V. Ledoux, *Japanese Prints by Harunobu and Shunshō in the Collection of Louis V. Ledoux*, 1945, No. 29.

Mr. and Mrs. Richard P. Gale, Mound, Minnesota.

The young lovers walk in the snow under a snow-covered umbrella. He is dressed in black and she in white, suggesting the classical pairing in painting of a black and a white bird. In another state of this print the keyblock outline on the top of the umbrella has been removed and changes have been made in certain details of the costumes and snowy willow branches.

56. Courtesan Looking at a Print

Book illustration from *Yoshiwara Bijin Awase (Beautiful Women of the Yoshiwara)*.
Signature: on wrapper, Suzuki Harunobu *hitsu*. 1770.
Publisher: Funaki Kasuke.
Full color print, single page, 10½ x 6½ inches.

The Art Institute of Chicago—Martin A. Ryerson Collection.

The courtesan Meizan, shown in this thirty-sixth portrait in the volume, looks at a print of a courtesan with attendants. On the floor lies the print wrapper with the inscription, *Azuma Nishiki-e,* and the artist's signature. *Yoshiwara Bijin Awase* is considered to be the masterpiece of Harunobu in book illustration. In the attitudes of the figures, in the arrangement of the patterns and kimonos there is endless variation. The colors are delicate and the drawings done with Harunobu's graceful but firm line.

春章

春
章

KATSUKAWA SHUNSHO, 1726—1792

Shunshō was the pupil of Katsukawa Shunsui who had been in turn a student of Miyagawa Choshun, a distinguished painter of genre subjects. Shunshō, abandoning the traditions of a school of painters who designed no prints, chose instead to enter the Torii field of actor prints, done in the technique made popular by Harunobu. His early work shows the influence of this artist in design and in the superb feeling for color. His true forte was in the depiction of actors

Plate 57 on stage in their leading roles, and this vision never left Shunshō as long as he designed in the print field. He realized the Torii weakness of merely using types to indicate the role, and instead conceived the idea of portraying the actual actors' individual features so that each might be recognized immediately. At first, actors of male roles were caught by the artist in dramatic and tense moments from the plays, but later Shunshō enlarged his scope to include female impersonation. This was an innovation in the history of *Ukiyo-e.* Shunshō placed the

Plate 65 single figure of the actor most effectively on the paper, so as to emphasize his importance, and, moreover, did not try to portray a realistic background. The stage set might be suggested by a few straight lines for buildings or a single line for the division of floor from wall. For outdoor scenes a simple curve indicated the ground, with a few bushes, flowers or the branch of a tree for atmosphere,

while a stream would be created with a few wavy lines. All this served to focus the viewer's attention on the actor and was done with aesthetic sensitivity. Shunshō was a prolific worker who designed many of his prints as triptychs and pentaptychs now only known to us as single sheets; in all probability Plate 61 was originally part of a larger composition.

Plate 60

Shunshō also portrayed the mightly wrestlers and created a few prints of strikingly handsome courtesans as well as scenes of actors in their dressing rooms. Shunshō cooperated in .the illustration of picture books with Bunchō and Shigemasa. Many critics regard the volume *Mirror of the Beautiful Women of the Green Houses* as his masterpiece.

Plate 58
Plates 63, 66, 67

Plate 59

Shunshō became the acknowledged leader of theatrical printmaking, dominating this field in the 1770's and into the late 1780's, and the prestige of his popularity enabled him to found the Katsukawa School. He was an outstanding teacher who numbered among his pupils some fine artists, the most famous of whom is, of course, Shunrō, better known as Hokusai. Shunshō was also an exceptional painter and to this he devoted the last years of his life. However, his fame rests on his superb dramatic portrait prints of the leading actors of the Kabuki stage whose careers coincided with his.

Plates 61, 62, 64

57. Katsukawa Shunshō. *Ichikawa Danjūrō in a Shibaraku Role. Late 1760's.*

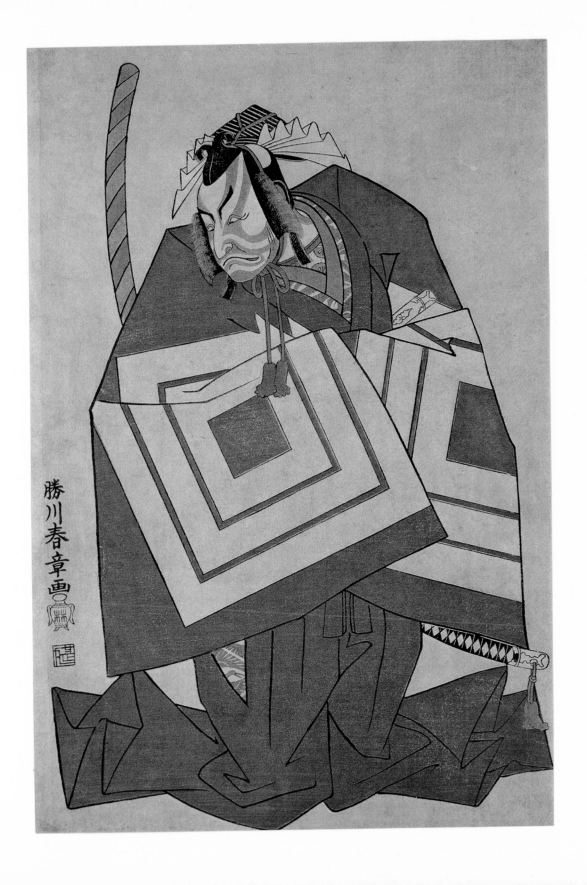

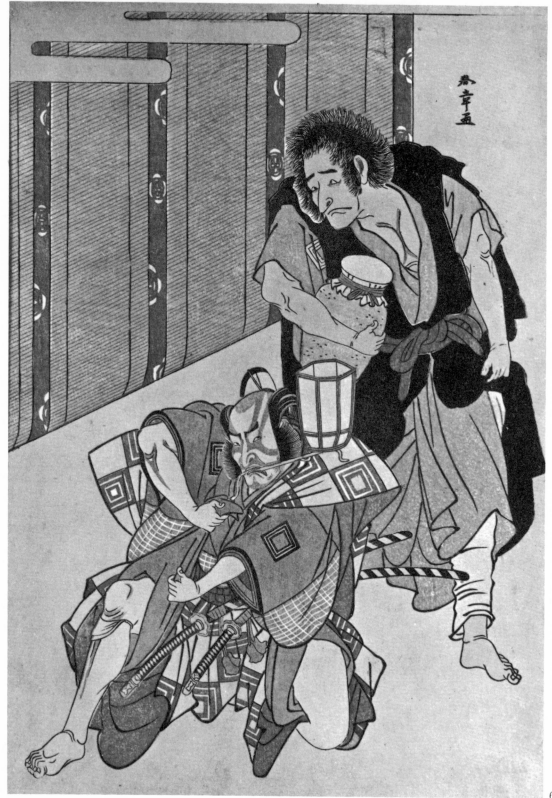

62.

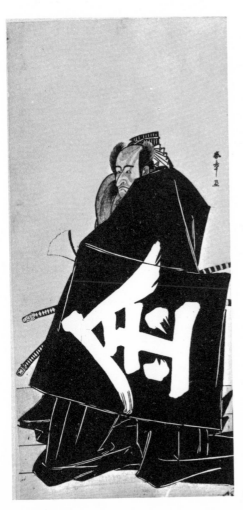

65.

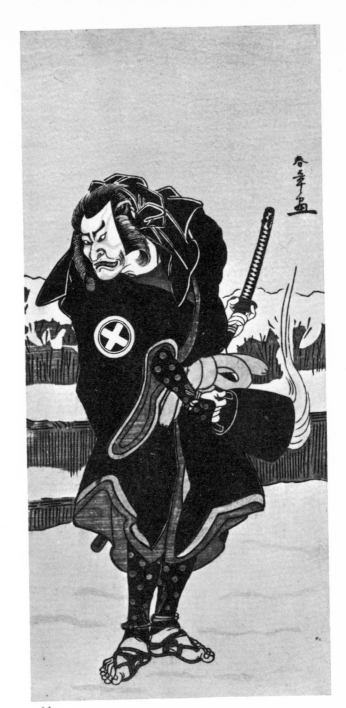

61.

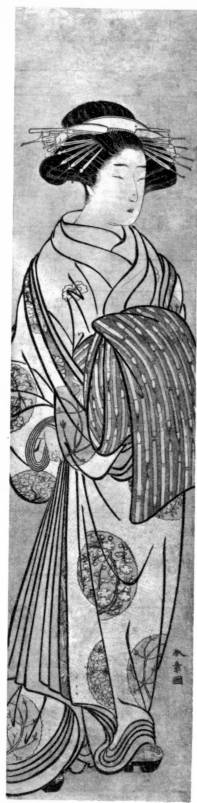

63.

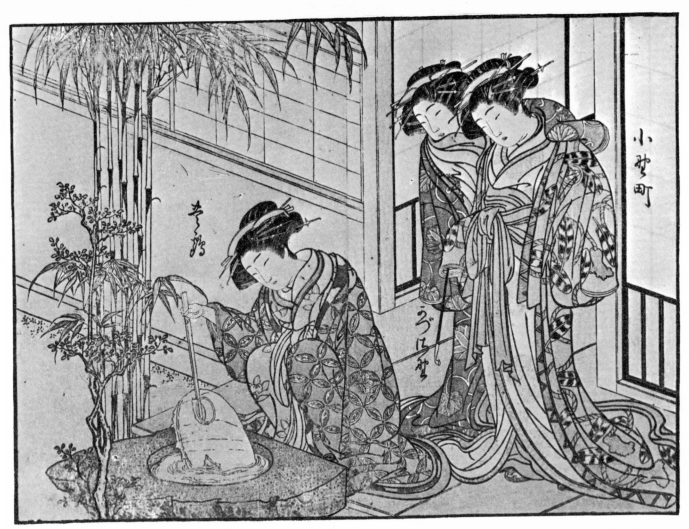

59.

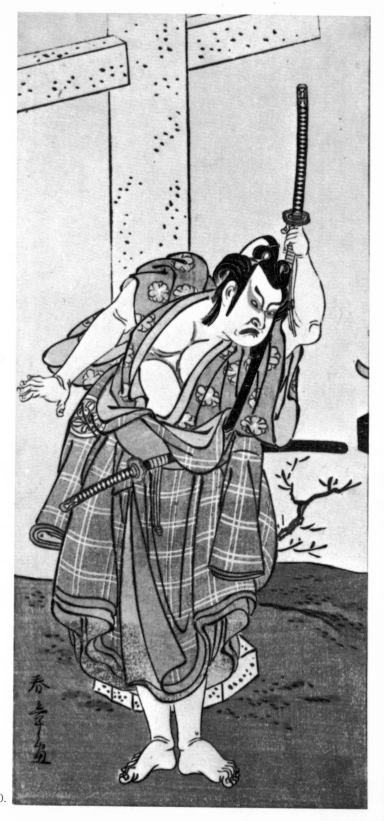

60.

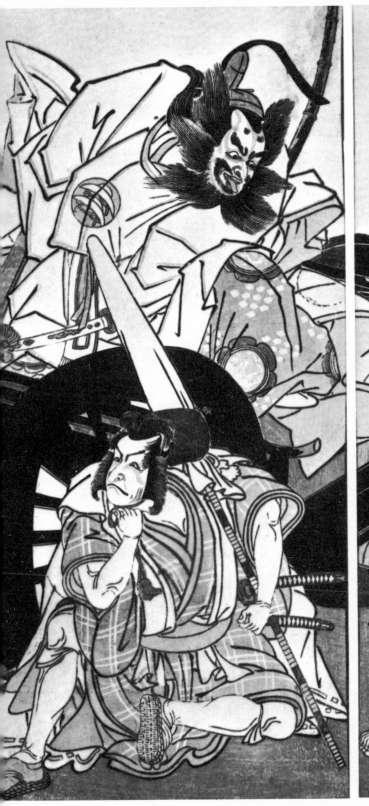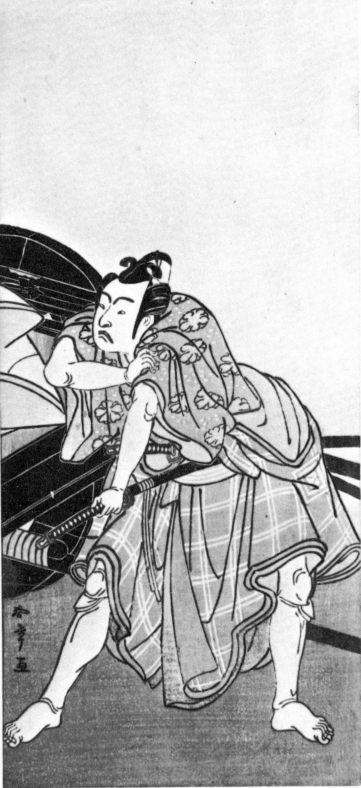

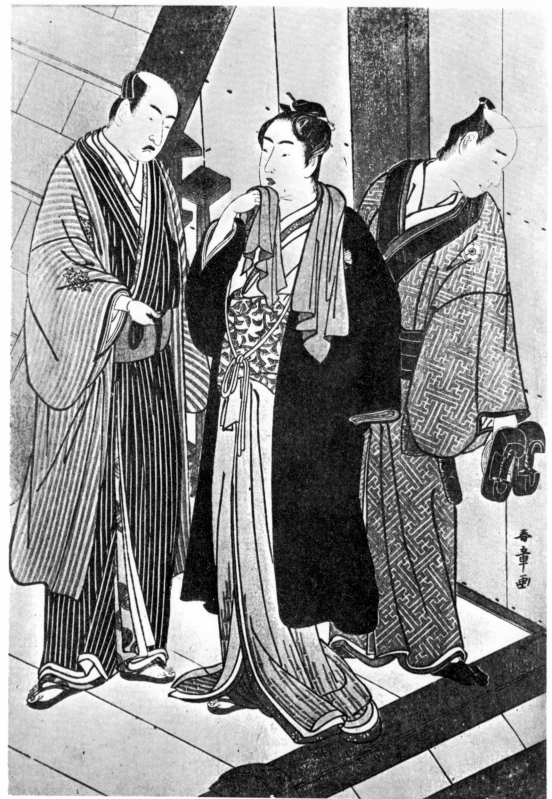

67.

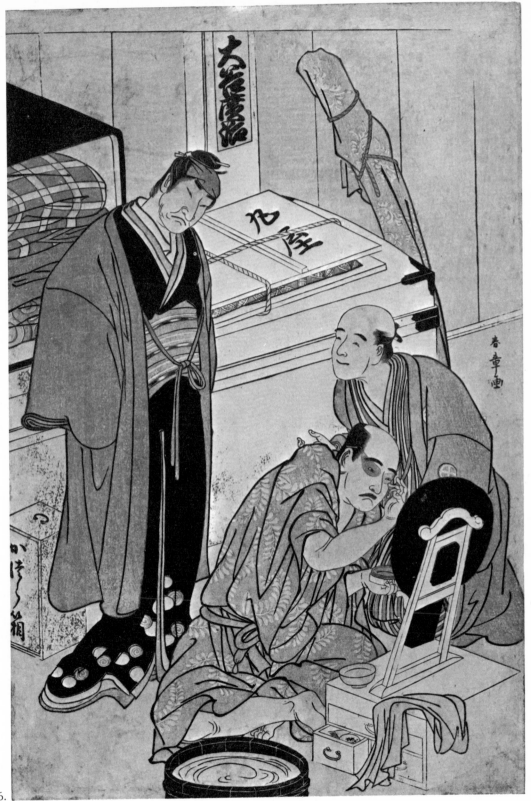

66.

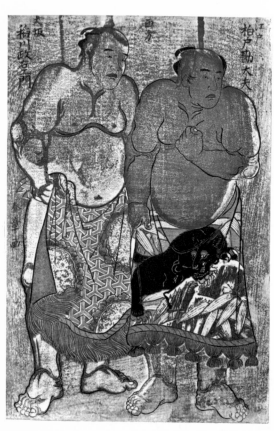

58.

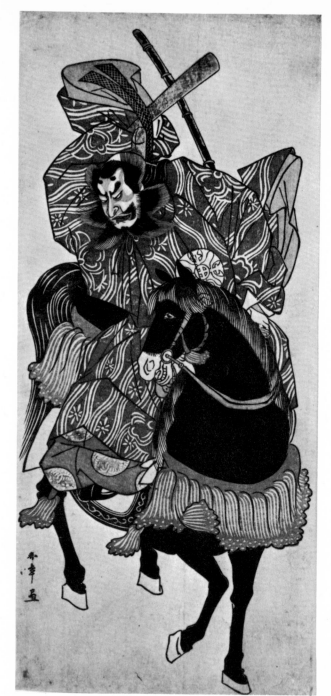

64.

57. Ichikawa Danjūrō IV in a Shibaraku Role

Signature: Katsukawa Shunshō *ga*. Jar seal: Hayashi. Late 1760's.
Publisher: Maruya.
Polychrome print, 15 x 10 inches.
Published: Edwin Grabhorn, *Figure Prints of Old Japan*. Printed for the Book Club of California, 1959, No. 43.

Edwin Grabhorn Collection, San Francisco.

The Ichikawa line of actors made a specialty of this role and it is one of the great dramatic moments in the theater when the actor comes posturing down the "flower walk" to call out "Shibaraku" ("Wait a Moment!"). The actor is traditionally dressed in a large brick-red robe with enormous sleeves, trailing trousers, and a stupendous sword. The crest of the Ichikawa line, three concentric squares in white, appears on the sleeves of the robe. The crossed eyes are a convention used by Kabuki actors in moments of dramatic intensity.

58. Two Famous Wrestlers of the West

Signature: Shunshō *ga*. Early 1770's.
Polychrome print, 15¼ x 10⅛ inches.

The Art Institute of Chicago—Clarence Buckingham Collection.

On the left is Kashiwado Kandayu of Edo; Inagawa Masaemon of Osaka is on the right. The print has oxidized giving a particularly pleasing effect of depth to the work.

59. Courtesan Removing Ice from the Cistern

Book illustration from *Seirō Bijin Awase Sugata Kagami (Mirror of Beautiful Women of the Green Houses)*.
Signature: Kakukawa Shunshō and Kitao Shigemasa. 1776.
Full color print, double page, 8⅞ x 12 inches.

The Art Institute of Chicago—Martin A. Ryerson Collection.

Shunshō and Shigemasa both designed for this picture book showing the daily life of courtesans in the four seasons. Frederick Gookin, an authority on Shunshō, felt the illustrations of courtesans in summer and winter are more reflective of Shunshō's painting style than are the other illustrations which seem more the work of Shigemasa.

60. Scene from a Drama

Signature: Shunshō ga. 1776.
Polychrome print, mounted as a triptych, 12⅛ x 16⅞ inches.

The Art Institute of Chicago—Clarence Buckingham Collection.

Four actors form a dramatic tableau in the play, "Sugawara Denju Tenari Kagami" performed at the Ichimura-za in 1776. Most of the prints by Shunshō were designed as diptychs, triptychs, and pentaptychs, but the purchaser might buy a single sheet of the composition or all according to his purse. Here the three prints were acquired over a number of years to reassemble the complete composition.

61. Ōtani Hiroemon IV as Yashotaro Tokihide

Signature: Shunshō ga. 1777.
Full color print, 12⅛ x 5½ inches.
Published: Louis V. Ledoux, *Japanese Prints by Harunobu and Shunshō in the Collection of Louis V. Ledoux,* 1945, No. 40,

Mr. and Mrs. Richard P. Gale, Mound, Minnesota.

62. The Actors Ichikawa Danjūrō V as Wantetsu the Renegade Priest, Holding a Jar, and Ichikawa Danzō IV Kneeling, in the Play "Date-Nishiki Tsui no Yumitori" at the Morita-za in 1778?

Signature: Shunshō ga. 1778.
Full color print, 19 x 13 inches.

Museum of Fine Arts, Boston—Nellie P. Carter Collection.

63. Courtesan

Signature: Shunshō ga. Late 1770's.
Polychrome print, 27¼ x 6⅝ inches.

The Art Institute of Chicago—Clarence Buckingham Collection.

The subject was formerly known as "Beauty With The Paint Brush Obi" because of the originality of the fabric's design.

64. Nakamura Nakazō I, probably as the Spirit of Masakado in "Shida Choja Bashira" at the Nakamura-za

Signature: Shunshō *ga*. 1781.
Full color print, 13 x 5³/₄ inches.
Published: Louis V. Ledoux, *Japanese Prints by Harunobu and Shunshō in the Collection of Louis V. Ledoux*, 1945, No. 37.

Collection of Honolulu Academy of Arts.

65. Ichikawa Danjūrō V in the Role of Sakata no Kintoki in "Shitenno Tonoi no Kisewata" at Nakamura-za

Signature: Shunshō *ga*. 1781.
Full color print, 12¹/₂ x 6 inches.
Published: Louis V. Ledoux, *Japanese Prints by Harunobu and Shunshō in the Collection of Louis V. Ledoux*, 1945, No. 46.

The Art Institute of Chicago—Clarence Buckingham Collection.

The play apparently recounted the exploits of four famous Japanese heroes, one of whom is the famous strong boy of the mountains who later in his career appeared on the Kabuki stage as one of the four personal body guards of Minamoto no Yorimitsu.

66. Ōtani Hiroji III Applying Make-up

Signature: Shunshō *ga*. 1782—according to Japanese experts.
Full color print, 15³/₈ x 10¹/₈ inches.

The Art Institute of Chicago—Clarence Buckingham Collection.

Yamashita Mangiku stands looking down at Hiroji applying make-up to his eyes while Ōtani Tokuki squats by the mirror stand talking to Mangiku. The inscription on the panel at top reads "Ōtani Hiroji," below "Maruya" (the house name of Hiroji) and at the lower left "wig box." Shunshō has taken us into the actor's dressing room where we can see Mangiku without make-up. The artist sees the sagging muscles of the face, the mean mouth, the furtive look in the eyes, and the tired, soft body of the actor.

67. At the Stage Entrance of a Theater

Signature: Shunshō *ga*. 1782.
Full color print, 14³/₄ x 9⁷/₈ inches.

The Art Institute of Chicago—Clarence Buckingham Collection.

The actors, from left to right, are Ichikawa Monnosuke II, Segawa Kikunojō III, and Iwai Harugoro.

清長

TORII KIYONAGA, 1752—1815

Kiyonaga, the son of a book dealer who was also a superintendent of tene-
ment houses, was a pupil of Kiyomitsu, the third successive head of the Torii
School, founded by Kiyonobu I, and carried on the tradition of designing actor
prints, playbills, and posters for the leading Kabuki theaters of Edō. Kiyonaga's
early work resembles that of his master. Later he imitated Shunshō's dramatic
renderings of actor portraits executed in polychrome technique, as well as
Koryūsai's prints of "beauties" which markedly affected his development and
Plate 68 use of color. By the 1780's Kiyonaga's own style was established and he produced
Plates 69, 71 series after series of prints that are among the glories of *Ukiyo-e*, depicting the
life and pageantry of the people of Edo he knew so well.

Kiyonaga carried on his responsibilities as Torii IV, designing actor prints in
new formats with an expanded vision and interpreting the stage in a more
realistic manner. Experimenting in a series of dancing scenes, Kiyonaga portrays
the stage as it appeared with chanters and musicians placed behind the actors.
Plate 70 shows such a design, outstanding in its color scheme, dramatic with
the intensity of the moment. Soon Kiyonaga dominated the field of *Ukiyo-e* with
his magnificent prints of graceful young women, fashionable young men and
beautiful courtesans of the gay quarters seen against detailed backgrounds. An
untitled series of prints of court ladies, dressed in their sumptuous robes with
unbound hair, is ranked high among Kiyonaga's noblest prints. Princess Ise, in
Plate 72 court robes with her young attendant, turns slightly to watch a flight of geese in

the soft spring mist. It was this sight that inspired her ode included in an anthology of the year 905. The stately figure is drawn with dignity and the artist has created a masterful composition with the balancing diagonal sweep of a flowering branch.

Kiyonaga was a prolific artist with a superb sense of color who left enough prints to satisfy all tastes though his primary vision was of an adult world inhabited by statuesque figures of regal proportions. Some of his finest prints were created in diptych and triptych format. In "Sudden Shower at Mimeguri," where *Plate 74* men and women run for the shelter of the gateway to escape the driving rain, *Plate 76* Kiyonaga admirably blends his figures with the landscape background to enrich the composition. The figures are shorter, nearer ordinary height, typical of his work at this time, as is his illustrated album of "Manners and Customs of the New Year" published in 1787. In the next few years he became less and less *Plate 75* productive until his virtual retirement from the field in the late 1780's.

Kiyonaga's talent and style dominated the 1780's and dazzled younger artists who fell under the spell of his feminine creations and deserted their respective masters to imitate him. His vision was a world of beauty filled with nobly proportioned people placed in pleasing surroundings, full of light and air. He *Plate 74* delineated this world with powerfully fluent and flexible brush strokes that added greater vividness of expression to his work. Kiyonaga was a great master of his art.

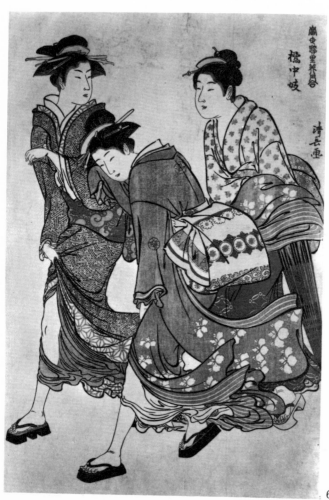

69.

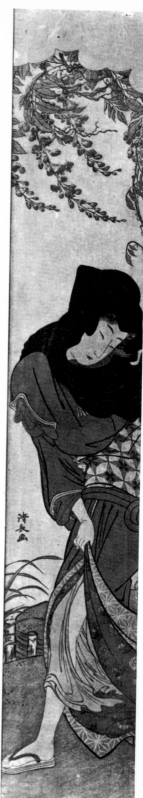

68.

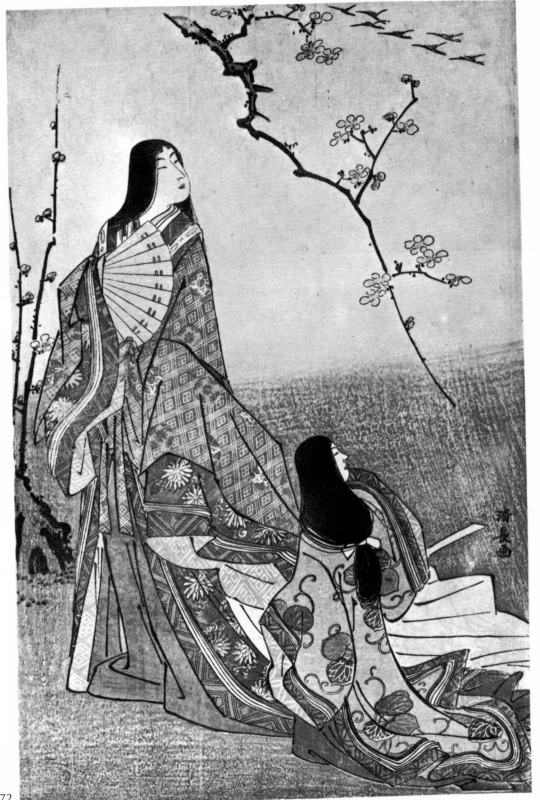

72.

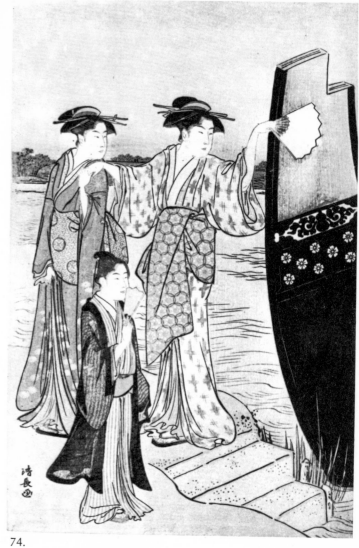

74.

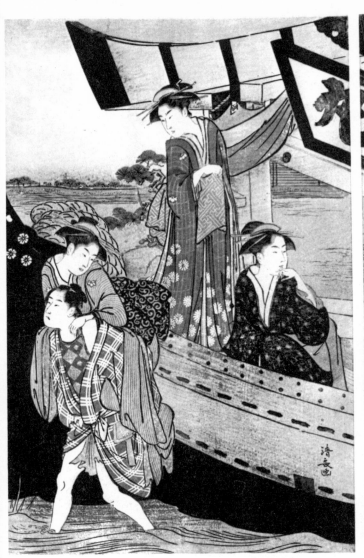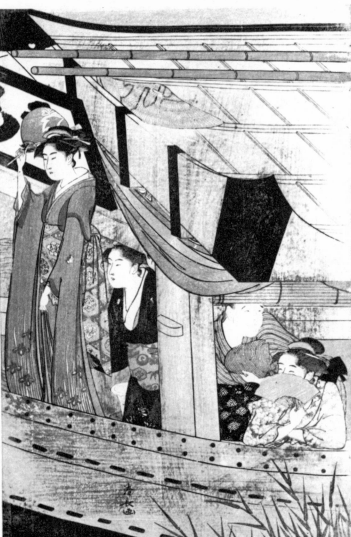

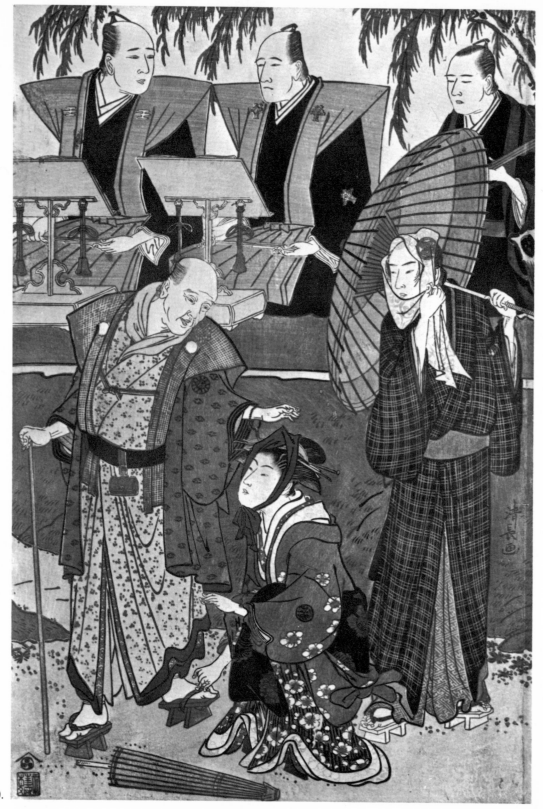

70.

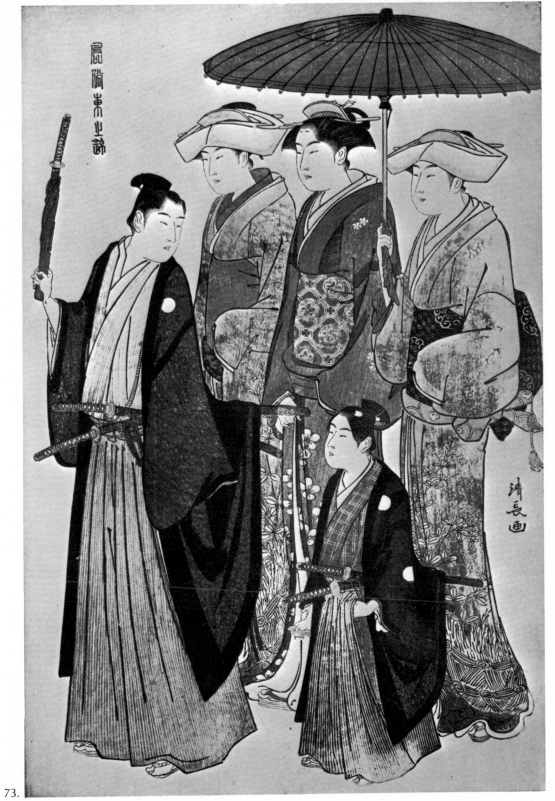

73.

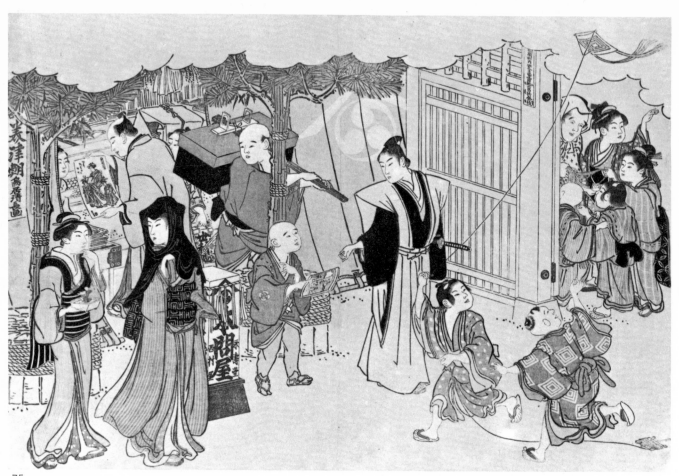

75.

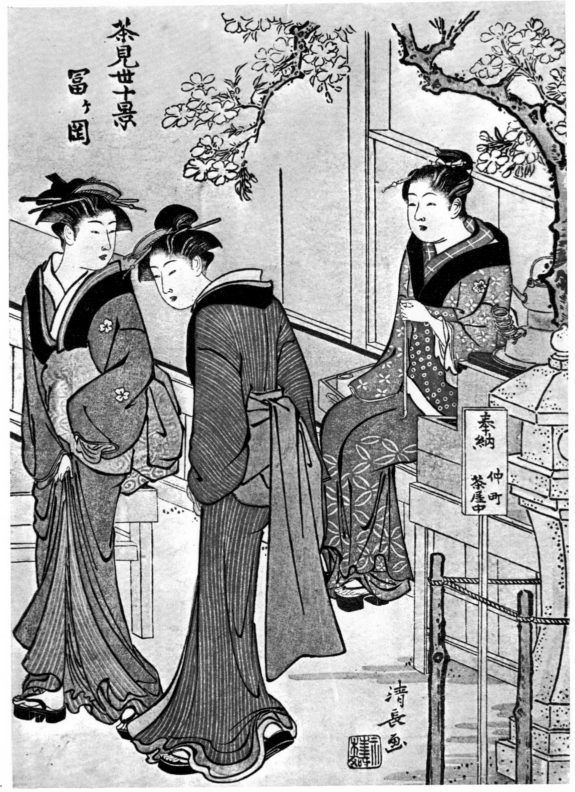

71.

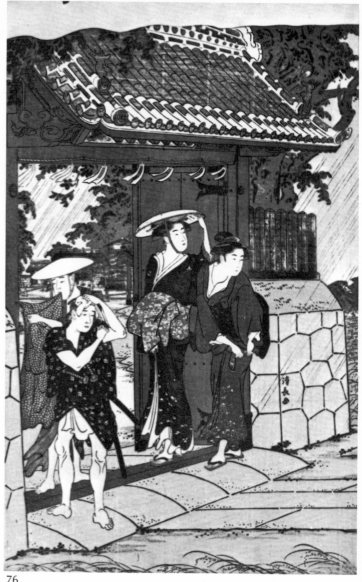

76.

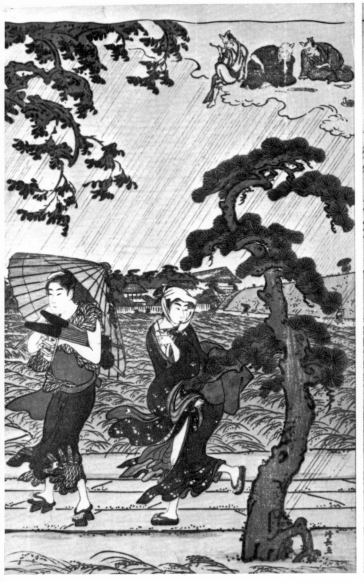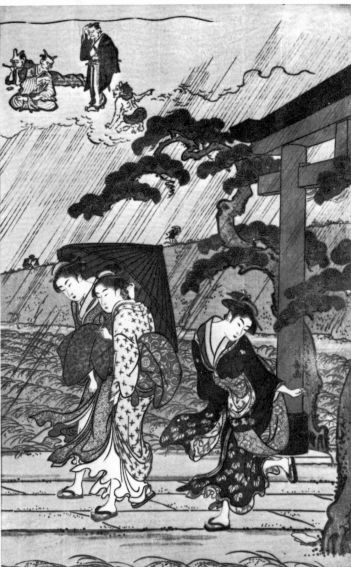

68. A Woman under Windblown Wisteria

Signature: Kiyonaga *ga*. Early 1780's.
Full color print, 27³/₈ x 4⁵/₈ inches.

The Art Institute of Chicago—Clarence Buckingham Collection.

Kiyonaga, Harunobu and Koryūsai are considered three of the finest designers of pillar prints. The figure of the woman bends gracefully in the wind while above her the wisteria echoes the curves of her figure and robes and proves Kiyonaga's mastery of the restricted pillar print proportions.

69. Dancers of Tachibana

Series: "A Contest of Fashionable Beauties of the Gay Quarters"
Signature: Kiyonaga *ga*. Early 1780's.
Full color print, 15³/₈ x 10¹/₄ inches.

Edwin Grabhorn Collection, San Francisco.

Kiyonaga designed twenty-one subjects for his series of "Fashionable Beauties" in the early 1780's which included sixteen single-sheet compositions and five diptychs. Here two geisha, followed by their maid carrying an umbrella, walk in the wind as they hold on to the skirts of their kimonos.

70. Scene from a Drama

Signature: Kiyonaga *ga*. 1783.
Full color print, 15 x 10 inches.

The Art Institute of Chicago—Clarence Buckingham Collection.

On the lower level are shown from left to right, Nakamura Katsugorō as Magoemon, Osagawa Tsuneyo as Umegawa, and Bandō Matakurō as Chūbei, the son of Magoemon and the lover of Umegawa. The play was performed at the Morita-za in April, 1783. On a raised background are seated two chanters, Tomimoto Buzen-dayū and Tomimoto Itsuki-dayū, with their accompanist Namizaki Tokuji. The tragic story of Chūbei and Umegawa was so popular on the Kabuki stage that any part could be presented and the audience would be familiar with the action that had preceded or was to follow. In essence, the story related how Chūbei had stolen money to buy the freedom of Umegawa from the pleasure quarter. The theft was discovered, the couple fled to his boyhood home where they hoped to obtain his father's forgiveness and then die together. In this episode the lovers have reached the village but hide as they fear their

arrest is imminent. Soon Chūbei's father passes by and falls. Umegawa decided she must go to the aid of the old man. Chūbei covers part of his face as though to hide from his father, while Umegawa is squatting to repair the broken strap of the old man's clog.

71. A Teahouse on the Grounds of Tomigaoka Shrine

Series: "Scene of Ten Teahouses"
Signature: Kiyonaga ga. Early 1780's.
Publisher: Nishimuraya.
Full color print, 10¼ x 7⅜ inches.

The Art Institute of Chicago—Clarence Buckingham Collection.

A sign by the stone lantern reads "dedicated by teahouse keepers at Nakachō."

72. Princess Ise Watching Flying Geese

Signature: Kiyonaga ga. Mid-1780's.
Full color print, 14⅞ x 9¾ inches.
Published: Louis V. Ledoux, Japanese Prints Bunchō to Utamaro in the Collection of Louis V. Ledoux, 1948, No. 22.

The Art Institute of Chicago—Clarence Buckingham Collection.

Princess Ise, one of the Thirty-six Immortal Poets, was the daughter of Fugiwara no Tsugikage and served the Empress Shichijo in the last quarter of the ninth century. The reference here is to a line in her ode: "Wild geese departing, forsaking the rising spring haze, did they once dwell in a village without cherry blossoms."

73. The Procession of a Young Nobleman

Series: "Beauties of The East as Reflected in Fashions"
Signature: Kiyonaga ga. Mid-1780's.
Full color print, 15½ x 10¼ inches.
Published: Chie Hirano, Kiyonaga: A Study of His Life and Works, Museum of Fine Arts, Boston, 1939, Pl. LV, No. 581.

The Art Institute of Chicago—Clarence Buckingham Collection.

The young nobleman with his two swords and holding a fan follows his retainer who holds up a short sword as he leads the way. The nobleman's mother walks between two ladies-in-waiting who wear headdresses of silk now worn only by brides.

74. Coming Ashore from a Pleasure Boat

Signature: Kiyonaga *ga*. Mid-1780's.
Full color print, triptych, 15³/₈ x 31¹/₈ inches.

The Art Institute of Chicago—Clarence Buckingham Collection.

75. Book Illustration—Street Scene before a Publisher's Shop

From *Saishiki Mitsu no Asa, (Morning of the New Year in Color)*.
Signature: Torii Kiyonaga. 1787.
Publisher: Nishimuraya.
Double page, 10 x 15 inches.

Museum of Fine Arts, Boston—Nellie P. Carter Collection.

The book from which this illustration is taken pictured the manners and customs of the New Year. An advertisement for the book appears on a sign at the extreme left. In the center foreground a boy apprentice of the shop shows a picture book to a youth, while in the rear a man inspects a print, possibly by Kiyonaga, of a courtesan with her two little attendants. Two women pass by the New Year decorations of pine and bamboo and the signpost of the publisher, Eijudo *han* Nishimura.

76. Sudden Shower at Mimeguri Shrine

Signature: Kiyonaga *ga*. Late 1780's.
Full color print, 15³/₈ x 30¹/₄ inches.

Mr. and Mrs. Richard P. Gale, Mound, Minnesota.

寫樂

TOSHUSAI SHARAKU, worked 1794—1795

The *Ukiyo-e* School is full of mysteries and unsolved problems concerning the lives of the artists who created its prints. The most spectacular, like a comet flashing across the sky of Edo, and certainly one of the most mysterious, was Sharaku. In the fifth month of 1794 there appeared a group of prints for the new production of a play at the Miyako-za by an artist hitherto unknown. This artist signed himself Sharaku and his genius is immediately apparent if one looks only *Plate 77* at his portrait of Miyako Dennai, the manager and director of the theater bearing his name. Of Sharaku we know practically nothing. Research reveals that he was a Nō dancer in the service of the Lord of Awa in whose suite he came to Edo. Here for the first time Sharaku came into contact with the popular Kabuki theater and the impact must have been tremendous. The difference between the sedate and aristocratic Nō performance and the bombast of the Kabuki was like being dropped into another world. The effect of this exposure we can see in *Plate 78* Sharaku's profound and passionate portraits of actors on stage, symbolizing the compulsion of the character by vividly emphasizing the facial expressions. A highly dramatic effect is achieved by placing flat colors against the dark, shim-*Plate 81* mering mica background and by using a soft, gray, modulated line for details of the face. Jet black accents the eyebrows, eyes, and mouth, and the result creates an immediate feeling of tension. One cannot help wondering what the effect on the public must have been when these prints were first viewed. Certainly they

marked a new psychological insight into the character of the actors and their roles.

Plate 79

Sharaku's prints and designs total about one hundred sixty, largely designed for definite Kabuki performances that can be actually dated, with some prints of famous wrestlers. All were done in a ten-month period, an amazing achievement for any artist. These few facts are all we know of this magnificent artist for Japanese sources, according to Henderson and Ledoux, tell us only that his prints lacked form and exaggerated the truth and therefore were not well received. An additional note in this Japanese history tells us "his name in private life was Saitō Jurobei. He was a Nō dancer in the service of the Daimyo of Awa. The power of his brush strokes and his taste are worthy of note. He was active for about half a year and produced bust portraits of actors . . ." However, Sharaku's talent was recognized by the great publisher Tsutaya Jusaburō who produced his prints, and later by a number of Japanese collectors, although it was the French who formed the great collections of his work and really understood him. It seems incredible that nothing is known of his early training for certainly no amateur, however gifted, could have created these powerful prints. The influence of Shunshō and some of his pupils has been noted in some of Sharaku's work, but this does not explain the penetrating portraits, fresh in concept and drawn with terrible emotion.

Plate 80

Plate 83

Plates 82, 84, 85

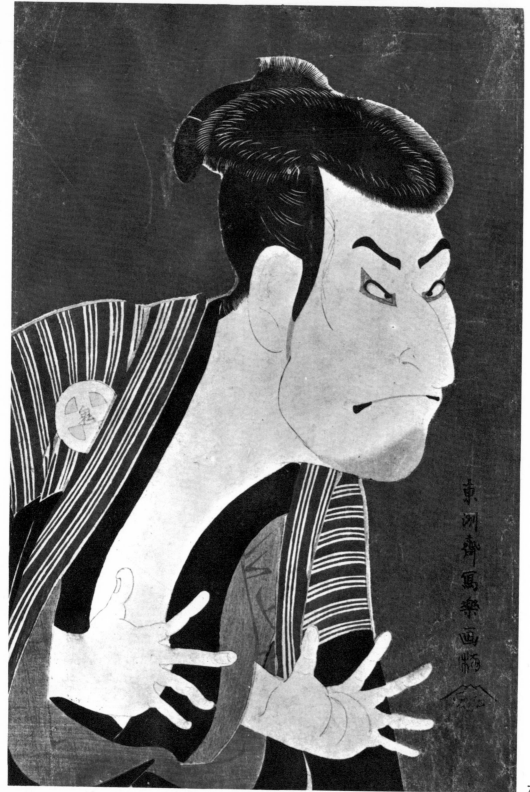

78.

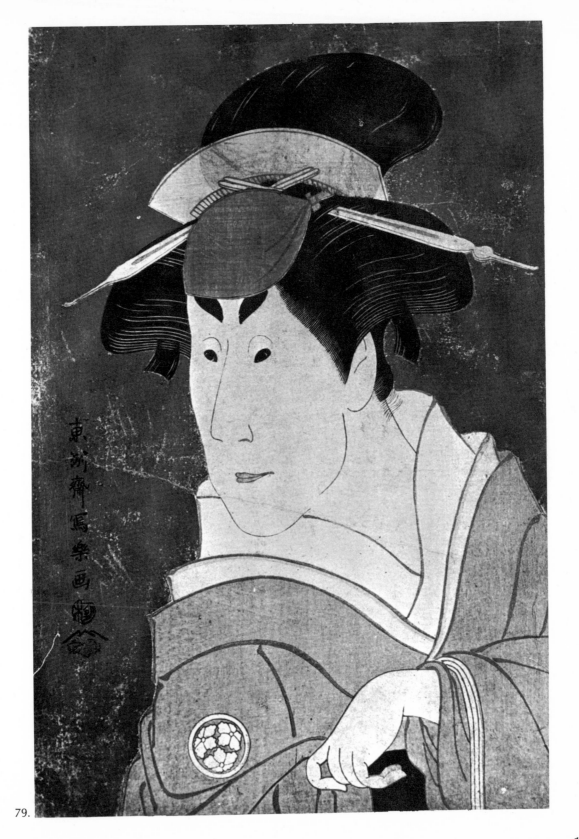

79.

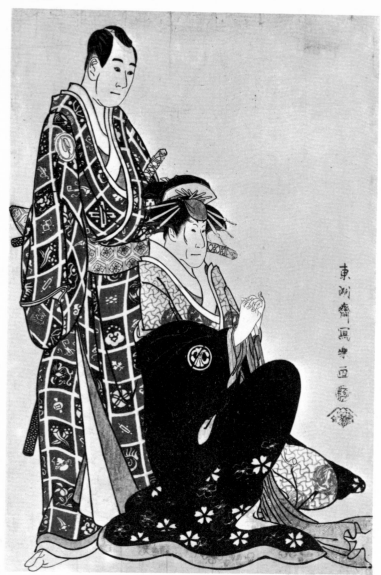

82.

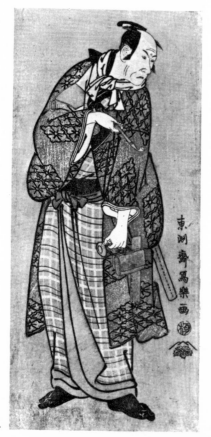

83.

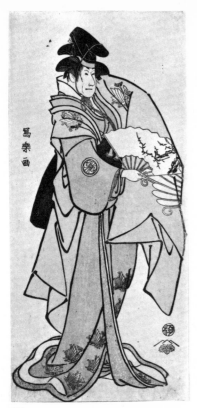

85.

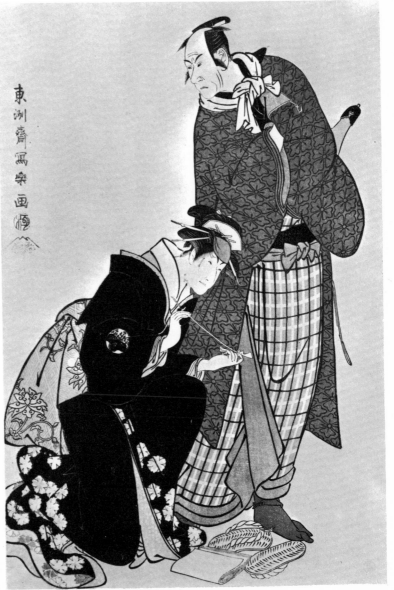

84.

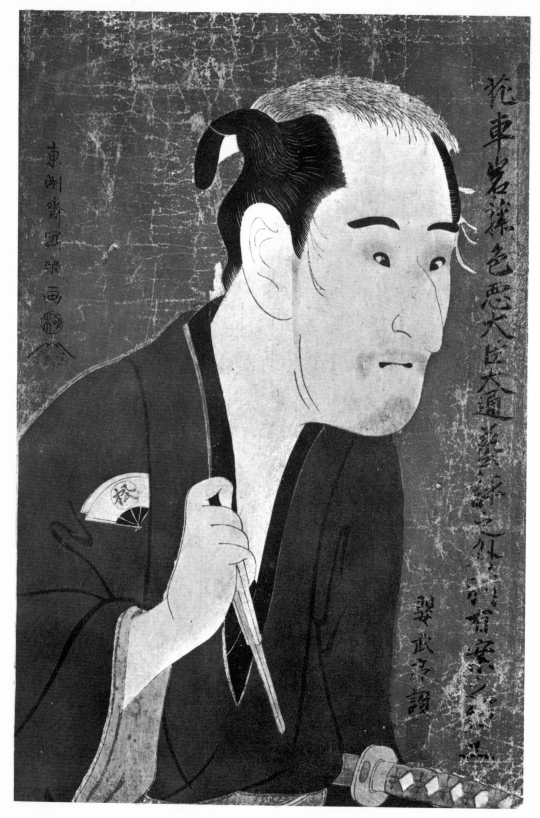

80.

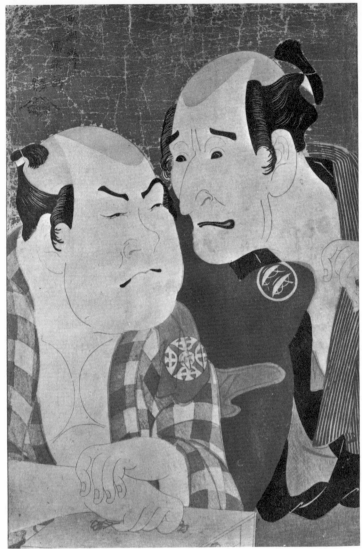

81.

77.

77. Portrait of Miyako Dennai III Reading an Announcement

Signature: Tōshūsai Sharaku *ga.* 1794.
Publisher: Tsutaya. Censor's seal: *kiwame.*
Full color print with mica, 14³/₈ x 10 inches.
Published: Henderson and Ledoux, *The Surviving Works of Sharaku,* 1938, No. 1, p. 41; Louis V. Ledoux, *Japanese Prints Sharaku to Toyokuni in the Collection of Louis V. Ledoux,* 1950, No. 17.

The Metropolitan Museum of Art—Whittelsey Fund, 1949.

Miyako Dennai had recently taken over the Miyako-za and raised it to one of the leading theaters in Edo by his important productions. His costume is covered with congratulatory wishes in the stylized design of the character for "Long Life." The print under discussion is the first state, the second shows an inscription on the scroll that the theater director is reading.

78. Ōtani Oniji III as Edohei

Signature: Tōshūsai Sharaku *ga.* 1794.
Publisher: Tsutaya. Censor's seal: *kiwame.*
Full color print with mica, 14³/₄ x 9³/₄ inches.
Published: Henderson and Ledoux, *The Surviving Works of Sharaku,* 1938, No. 19, p. 90.

The Art Institute of Chicago—Clarence Buckingham Collection.

Oniji plays the part of a *yakko* or manservant of a type employed by samurai to perform deeds of violence.

79. Osagawa Tsuneyo II probably as Ayame

Signature: Tōshūsai Sharaku *ga.* 1794.
Publisher: Tsutaya. Censor's seal: *kiwame.*
Full color print with mica (repair in mica at right above signature), 14³/₈ x 9¹/₂ inches.

The Art Institute of Chicago—Clarence Buckingham Collection.

80. Onoe Matsusuke I as Matsushita Mikinojō

Signature: Tōshūsai Sharaku *ga.* 1794.

Publisher: Tsutaya. Censor's seal: *kiwame*.
Full color print with mica, 15 x 10 inches.
Published: Henderson and Ledoux, *The Surviving Works of Sharaku*, 1938, No. 25, p. 108.

The Art Institute of Chicago—Clarence Buckingham Collection.

The long inscription at the right was written and signed by Ueyda Shikibuchi (1819-1879), who was presumably a former owner of the print. It speaks of Matsusuki's fame as an impersonator of old women, and the Iwafuji, malefactors of rank and rich men addicted to high living.

81. Nakamura as Konozō the Homeless Boatman, Kanagawaya no Gon, being Cursed by Nakajima Wadaemon as Bōdara no Chōzaemon, the Dried Codfish

Signature: Tōshūsai Sharaku *ga*. 1794.
Publisher: Tsutaya. Censor's seal: *kiwame*.
Full color print with mica, 15⅛ x 10 inches.
Published: Henderson and Ledoux, *The Surviving Works of Sharaku*, 1938, No. 29, p. 118.
Louis V. Ledoux, *Japanese Prints Sharaku to Toyokuni in the Collection of Louis V. Ledoux*. Princeton, 1950, No. 21.

The Metropolitan Museum of Art—Dick Fund, 1949.

As Louis Ledoux so succinctly wrote in *The Surviving Works of Sharaku*, "This is one of Sharaku's most masterly characterizations, and it is to be regretted that recent findings make it impossible to call the print any longer by the old, felicitous title: A Wrestler Being Cursed by His Manager. The types are the same; but one has grown accustomed to imagining happily what the supposed wrestler had done or failed to do, and now it is necessary to follow thought down strange new alleys that lead to all the possible malefactions of boatmen."

82. Segawa Kikunojō III as the Courtesan Katsuragi, the Heroine in the Play, and Sawamura Sōjūrō III as Nagoya Sanza, the Hero

Signature: Toshusai Sharaku *ga*. 1794.
Publisher: Tsutaya. Censor's seal: *kiwame*.
Full color print with mica, 15 x 10 inches.
Published: Henderson and Ledoux, *The Surviving Works of Sharaku*, 1938, No. 43, p. 144.

The Art Institute of Chicago—Clarence Buckingham Collection.

83. Matsumoto Kōshirō IV as Magoemon

Signature: Tōshūsai Sharaku *ga*. 1794.
Publisher: Tsutaya. Censor's seal: *kiwame*.
Full color print, 12¼ x 5¾ inches.
Published: Henderson and Ledoux, *The Surviving Works of Sharaku,* 1938, No. 63, p. 178.

The Art Institute of Chicago—Clarence Buckingham Collection.

84. Matsumoto Kōshirō IV as Mageomon and Nakayama Tomisaburō as Umegawa

Signature: Tōshūsai Sharaku *ga*. 1794.
Publisher: Tsutaya. Censor's seal: *kiwame*.
Full color print with mica, color and mica strengthened by later retouching, 15 x 9⅞ inches.
Published: Henderson and Ledoux, *The Surviving Works of Sharaku,* 1938, No. 62, p. 176.

Fogg Art Museum, Harvard University, (A. B. Duel Collection).

For the story of Umegawa see Kiyonaga, Plate 70.

85. Segawa Kikunojō III as a Dancer

Signature: Sharaku *ga*. 1794.
Publisher: Tsutaya. Censor's seal: *kiwame*.
Full color print, 12⅜ x 5¾ inches.
Published: Henderson and Ledoux, *The Surviving Works of Sharaku,* 1938, No. 129, p. 295. Louis V. Ledoux, *Japanese Prints Sharaku to Toyokuni in the Collection of Louis V. Ledoux,* 1950, No, 10.

The Metropolitan Museum of Art—Whittelsey Fund, 1949.

長喜

EISHOSAI CHOKI, worked ca. 1770's to 1800's

Very little is known about the life of Chōki. We first hear of him as a pupil of Sekien who also taught Utamaro. The book illustrations and prints by Chōki are strongly influenced, as was the case with so many of his contemporaries, first by Kiyonaga and then Utamaro. There is also a pillar print by Chōki of a girl holding a fan, decorated with an image of a Sharaku actor, showing his admiration for this artist. In the late 1780's and for a few years thereafter Chōki matured as an artist, leaving us prints of surpassing grace, outstanding among the color prints of Japan in their expression of feminine beauty.

Plate 86 The striking characteristic of these half-length portraits is Chōki's mannerism of placing the upright line of the figure close to the margin of the print and sometimes almost parallel to it. There is a narrowing of the shoulders, an emphasis on the face, and an alertness about the eyes that is unusual. These figures are drawn sharply and with keen insight, against mica or yellow backgrounds, and they produce a bewitching vision that stirs us in a disquieting way.

Plate 88 In "Catching Fireflies", a girl and a young boy stand against a dark, luminous sky alive with the glow of these tiny creatures. Chōki created out of this genre scene a superb composition with an emotional depth unusual in *Ukiyo*-e.

There are some collectors who may feel the inclusion of Chōki among the giants of the print school is unwarranted, were one to judge him by the total output of his prints. However, the three prints included here have been taken from a known group of a dozen superb designs, uniquely Chōki's own creations. They may represent a synthesis of styles of other artists—Kiyonaga, Utamaro, Eishi, Sharaku—and they may reflect a little of the quality of Bunchō, but they stand apart in the use of color, in a different approach to the treatment of the figure, and in a feeling of tension. As with the prints of Sharaku, once seen they are never forgotten.

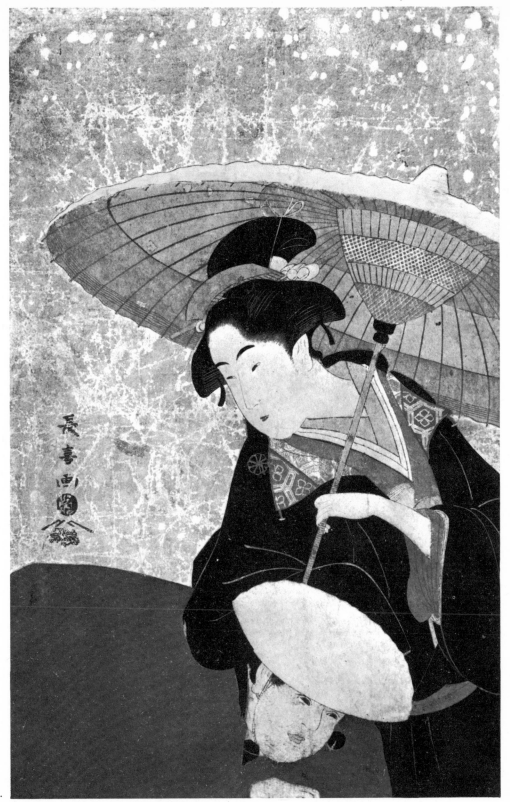

87.

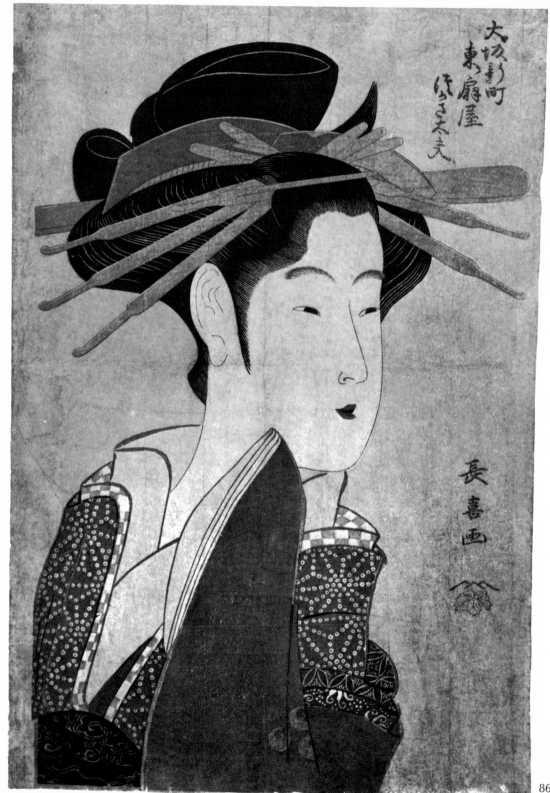

大坂り新町
東扇屋
佐々太夫

長喜画

86.

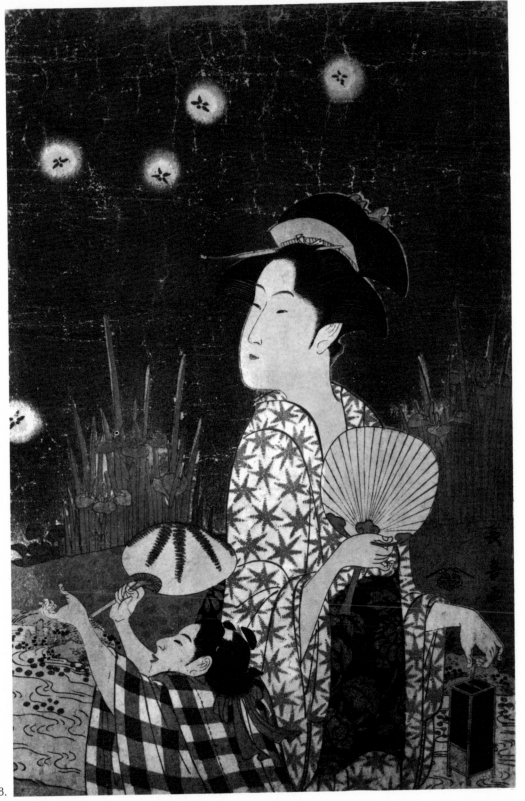

88.

86. The Courtesan Tsukasa of Ōgiya in Osaka

Signature: Chōki *ga*. Mid-1790's.
Publisher: Tsutaya.
Full color print with mica, 15½ x 10¼ inches.
Published: James A. Michener, *Japanese Prints From The Early Masters To The Moderns*, 1959, No. 173, p. 158.

From the Michener Collection, Honolulu Academy of Arts.

87. Girl and her Manservant in Snow

Signature: Chōki *ga*. Mid-1790's.
Publisher: Tsutaya. Censor's seal: *kiwame*.
Full color print with mica, 15 x 9¾ inches.
Published: James A. Michener, *Japanese Prints From The Early Masters To The Moderns*, 1959, No. 174, p. 160.

From the Michener Collection, Honolulu Academy of Arts.

88. Catching Fireflies

Signature: Chōki *ga*. Mid-1790's.
Publisher: Tsutaya. Censor's seal: *kiwame*.
Full color print with mica, 15 x 9¾ inches.
Published: Edwin Grabhorn, *Figure Prints of Old Japan*. The Book Club of California, 1959, No. 37.

Edwin Grabhorn Collection, San Francisco.

哥麿

KITAGAWA UTAMARO, 1753—1806

As a youth, the celebrated artist we know as Utamaro entered the school of Toriyama Sekien. This painter had his training in the Kanō School, which insisted on long hours of practice with the brush. Apart from painting, Sekien illustrated books, was fond of poetry and light verse, and was a teacher of influence who numbered among his friends actors, playwrights, and the literary and artistic men who inhabited the gay places around town. It was probably through Sekien's circle of friends that Utamaro first met the famous Edo publisher, Tsutaya Jusaburō, known as Tsutajū, who was associated with some of the great Edo artists and the most creative enterprises in the publishing field of *Ukiyo-e*. Tsutajū had not only the gift of discovering genius but also the ability to develop it to the fullest. Several artists and writers were attached to his household when, in 1783, Utamaro made his home with the publisher.

Plate 89 From this time Utamaro's work grew in scope. His early illustrated books and prints, the first published in 1775, are not impressive and the influence of Shunshō the reigning designer of actor prints is noticeable. During the early 1780's the influence of Kitao Masanobu, whose work Tsutajū was publishing, is evident in Utamaro's designs, but it is to Kiyonaga that he really owes his greatest debt. From the mid-1780's on, he produced numerous single prints as well as triptychs in Kiyonaga's style. Utamaro's personal style, however, had emerged when, in

1788, Tsutajū published his *Insect Book,* a masterpiece of printing with an origi- *Plate 90*
nality of conception unusual in the field of nature studies. This was followed by
a book on shells and birds in the following year, of the same high quality and
with the same meticulous delicacy of drawing. *Plate 91*

From 1790 we find Utamaro creating pictures of women in his own fully
mature style. One's attention is focused on the physical beauty of these women,
often pictured in three-quarter view against a plain background of color or a *Plate 93*
gleaming surface of mica. The emphasis here seems to be on color values and a
suppleness of line that bring out the warmth and freshness of the skin tones and *Plates 94, 96*
the lovely facial features of his beauties. This is well illustrated by his masterful
portrait of O-Kita. Utamaro has been called a decadent because so many of his *Plate 95*
prints depict the inhabitants of the Yoshiwara where he undoubtedly spent a *Plate 98*
great deal of his time, but his total oeuvre includes a wide range of subject mat-
ter that has nothing to do with the Yoshiwara. In Plate 99, we see his tender
treatment of mother love showing Yamauba and the ruddy-skinned little boy
Kintoki as he lovingly clings to her and, with one foot off the ground, strains to
gain the chestnut she holds.

Yet Utamaro's fame rests on his pictures of the beauties of his day, those lovely
girls, graceful and desirable, who inspired his vision with great artistry. *Plates 97, 100*

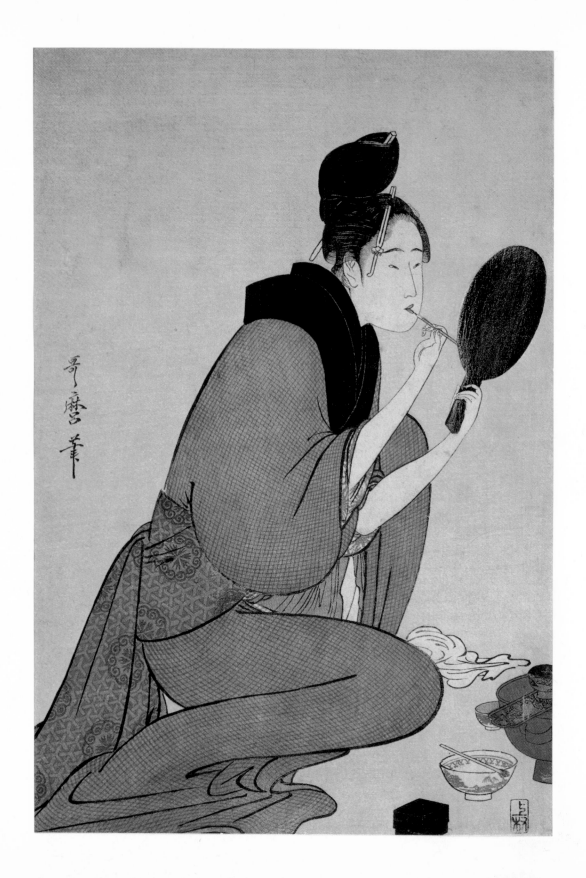

96. Kitagawa Utamaro. *Painting Her Lips*. Mid 1790's.

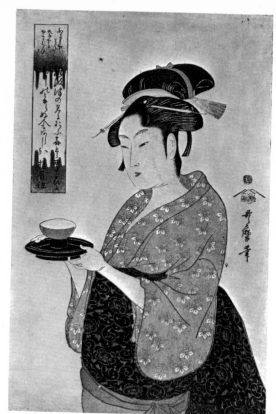

95.

90.

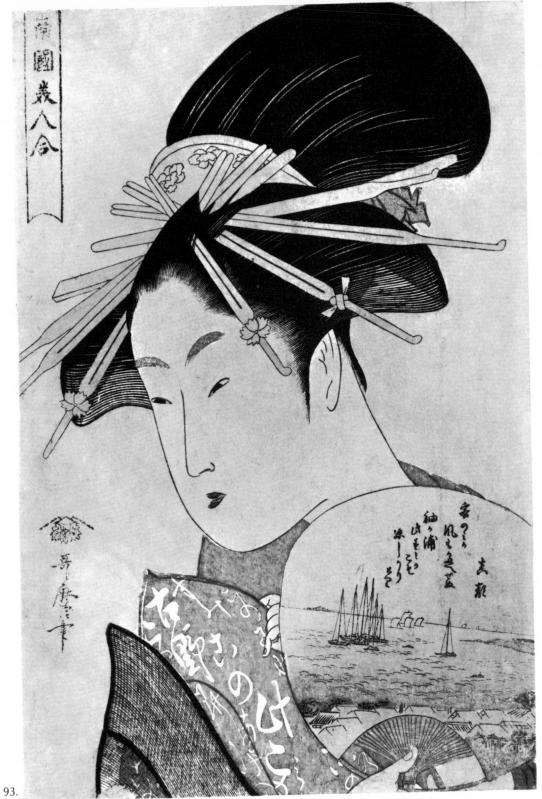

93.

91.

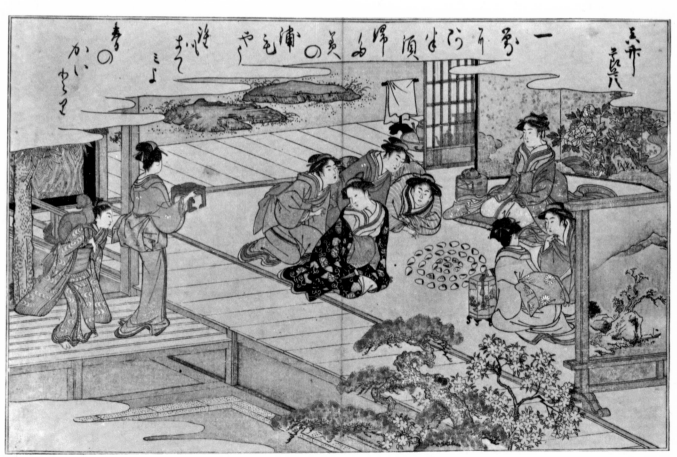

92.

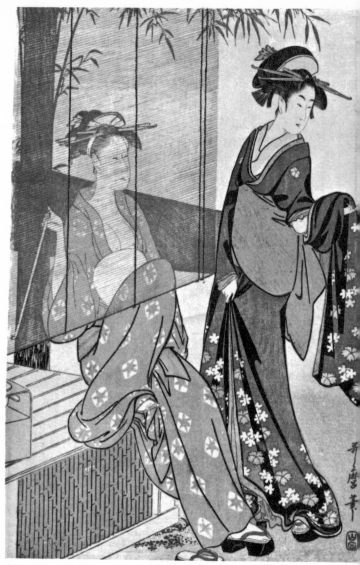

97.

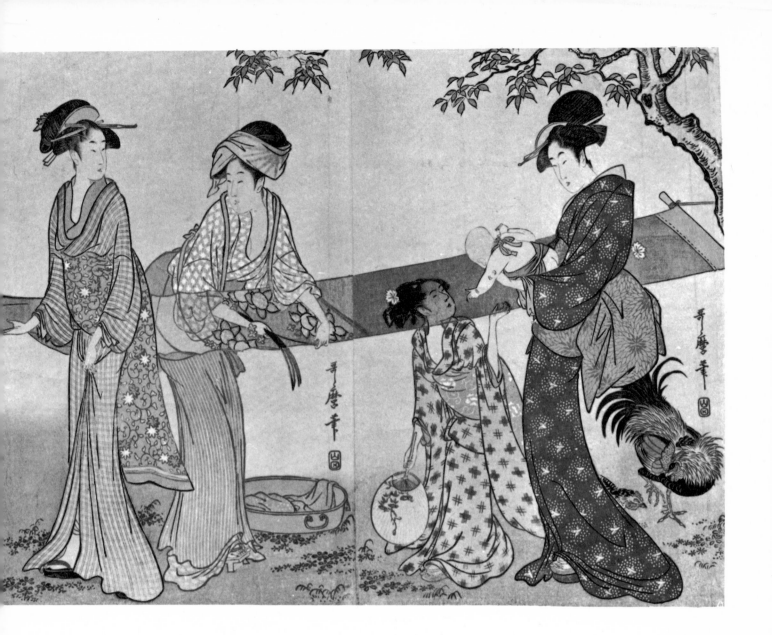

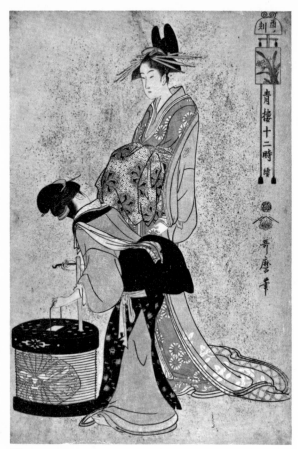

98.

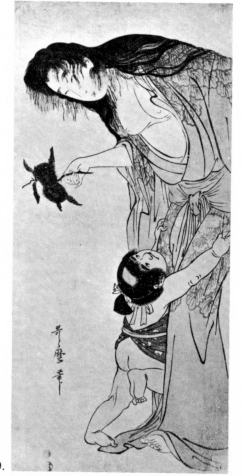

99.

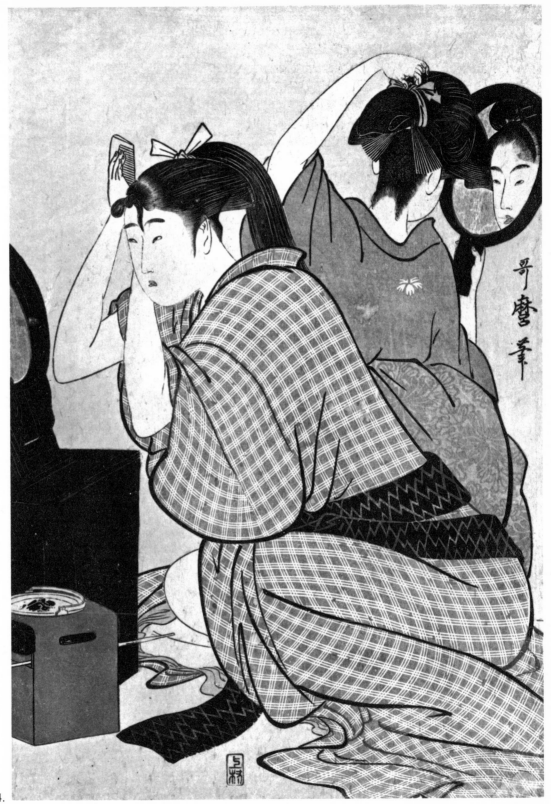

94.

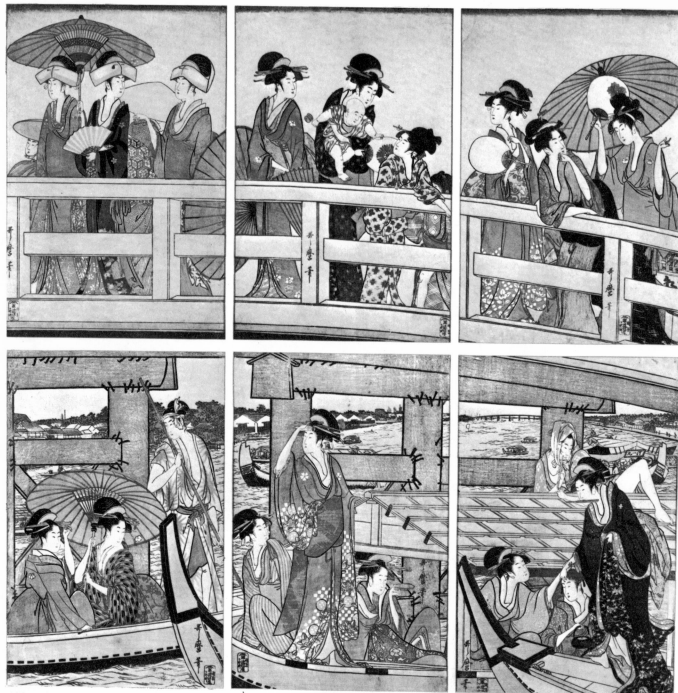

100.

89. Rising Sun and Tsukuda Island seen beneath Eitai Bridge on New Year's Morning

Signature: Utamaro ga. 1785.
Full color print, *surimono*. 19¼ x 22½ inches.

The Art Institute of Chicago—Clarence Buckingham Collection.

Surimono are special prints issued for New Year's greetings and announcements. Upon the pillars supporting the bridge humorous odes by eight poets are printed. Following are free English translations of the odes:

1. The haze rises at the pier of Tsukudajima where the boats come in with the New Year.
2. The haze spreads over the peaceful calm of the sea at Teppozu on New Year's.
3. Through the tangle of weeds of the old year comes slowly slithering the New Year of the Snake.
4. Yelling hurrah! the courier of the New Year has just arrived at Eitaibashi this morning.
5. The waves come visiting from off coast in the morning, and the port is open to welcome the New Year.
6. So that all will go well in the New Year, let us pray in the the right direction for luck.
7. With our New Year offering, our hearts are calm with Wisdom, Benevolence and Courage.
8. Looking out over the bay, still in the winter of the year, the masts of the New Year suddenly appear.

90. Book Illustration—Insect and Flowers

From *Ehon Mushi Erabi (A Picture Book of Selected Insects)*.
Signature: Kitagawa Utamaro *hitsu*. 1788.
Publisher: Tsutaya.
Double page, 10½ x 13¼ inches.

Lent by Merlin and Mary Ann Dailey, Memphis.

91. Book Illustration—New Year's Day Celebration with Performing Monkey

From *Waka Ebisu (New Scene of Ebisu Day)*.
Signature: Kitagawa Utamaro. Second Edition (First Edition dated 1789).
Double page, 10⅛ x 14⅞ inches.

Museum of Fine Arts, Boston—Morse Collection.

92. Book Illustration—Playing the Shell Game

From *Shiohi no Tsuto (Souvenirs From Ebb Tide)*.
Signature: Kitagawa Utamaro *zu*. Early 1790's.
Double page, 10¾ x 15¼ inches.

Museum of Fine Arts, Boston—Morse Collection.

93. Courtesan Holding a Fan

Series: "Beautiful Girls of the South"
Signature: Utamaro *hitsu*. Early 1790's.
Publisher: Tsutaya.
Full color print, 14¾ x 9¾ inches.
Published: Louis V. Ledoux, *Japanese Prints Bunchō to Utamaro in the Collection of Louis V. Ledoux*, 1948, No. 43.

Mr. and Mrs. Richard P. Gale, Mound, Minnesota.

The courtesan's fan pictures Edo Bay and a poem by Magao, a contemporary writer. Louis Ledoux has translated the verse to read:

> Even as guests do,
> So do the summer breezes,
> Ever returning,
> Come to Sodegaura;
> Place of heavenly coolness.

He suggests the print might be a record by the artist and poet who had enjoyed a summer outing, rather than a commission from the proprietor to advertise his establishment.

94. Two Women Dressing their Hair

Signature: Utamaro *hitsu*. Early 1790's.
Publisher: Uemura.
Full color print, 14¼ x 9¾ inches.

Prints Division, The New York Public Library.

95. Portrait of O-Kita of the Naniwa-ya

Signature: Utamaro *hitsu*. Mid-1790's.
Publisher: Tsutaya. Censor's seal: *kiwame*.
Full color print, 14¾ x 9⅜ inches.
Published: Louis V. Ledoux, *Japanese Prints Bunchō to Utamaro in the Collection of Louis V. Ledoux*, 1948, No. 44.

Mr. and Mrs. Richard P. Gale, Mound, Minnesota.

The poem is signed with the fanciful name Katsura no Mayuzumi and has a heading, "written while resting at Naniwa-ya." The poem contains a compliment to O-Kita and says travelers are as sure to stop at the famous Naniwa-ya to look at the pretty waitress, as they are to visit the post station and harbor for which it was named.

96. Painting her Lips

Signature: Utamaro *hitsu*. Mid-1790's.
Publisher: Uemura.
Full color print, 14¼ x 9¾ inches.

Prints Division, The New York Public Library.

97. Girls Drying Cloth

Signature: Utamaro *hitsu*. Late 1790's.
Publisher : Yamada.
Full color print, triptych, 15 x 30¼ inches.

Prints Division, The New York Public Library.

98. The Hour of the Cock, 5 to 7 P.M.

Series: "Twelve Hours in The Green Houses"
Signature: Utamaro *hitsu.* Late 1790's.
Publisher: Tsutaya. Censor's seal: *kiwame.*
Full color print, 14⅞ x 10 inches.

Prints Division, The New York Public Library.

The maid is preparing a lantern to light the way of the courtesan in the evening parade of the Yoshiwara.

99. Yamauba and Kintoki

Signature: Utamaro *hitsu.* Late 1790's.
Publisher: Marutaya.
Full color print, 19¾ x 9¼ inches.

The Art Institute of Chicago—Clarence Buckingham Collection.

100. Above and Below Ryogoku Bridge

Signature: Utamaro *hitsu.* Late 1790's.
Publisher: Omiya.
Full color print, double triptych, 30⅛ x 30⅛ inches.

The Art Institute of Chicago—Clarence Buckingham Collection.

Toyokuni who copied Utamaro's designs and ideas, is the only other *ukiyo*-e artist who is known, so far, to have designed a double triptych.

SELECT BIBLIOGRAPHY

Binyon, Laurence. *A Catalogue of Japanese and Chinese Woodcuts . . . in the British Museum*. London: The British Museum, 1916.

Binyon, Laurence and Sexton, J. J. O'Brien. *Japanese Colour Prints*. London, 1923, reprinted in 1960.

Bowers, Faubion. *Japanese Theatre*. New York, 1952.

Ernst, Earle. *The Kabuki Theatre*. London, 1956.

"An Exhibition of Masterpieces of Ukiyo-e," Introduction by Dr. Muneshigi Narazaki. *Ukiyo-e Art* (Tokyo), Number Three, 1963.

Ficke, Arthur Davison. *Chats on Japanese Prints*. London, 1915; reprinted, Rutland, Vermont, 1958.

———"The Prints of Kwaigetsudō." *The Arts*, New York, Vol. IV, No 2, 1923.

Gentles, Margaret. *Harunobu, Koryusai, Shigemasa and Their Contemporaries*. Chicago: The Art Institute of Chicago, 1964.

Gookin, F. W. *Japanese Colour Prints and Their Designers*. New York, 1913.

Grabhorn, Edwin. *Figure Prints of Old Japan. A Pictorial Pageant of Actors & Courtesans of the Eighteenth Century Reproduced from the Prints in the Collection of Marjorie and Edwin Grabhorn*. San Francisco: The Book Club of California, 1959.

Gunsaulus, Helen C. *The Clarence Buckingham Collection of Japanese Prints: The Primitives*. Portland: The Art Institute of Chicago, 1955.

Hillier, J. *Japanese Masters of The Colour Print*. London, 1954.

———*The Japanese Print: A New Approach*. Rutland, Vermont, 1960.

———*Utamaro: Colour Prints and Paintings*. Greenwich, Conn., 1961.

Hirano, Chie. *Kiyonaga: A Study of His Life and Works*. With a Portfolio of Plates. Boston, 1939.

Joly, Henry L. *Legends in Japanese Art*. London, 1908.

Kondo, Ichitaro. *Suzuki Harunobu*. ("Library of Japanese Art," No. 7.) Rutland, Vermont, 1956.

———*Tōshūsai Sharaku* ("Library of Japanese Art," No. 2.) Rutland, Vermont, 1955.

———*Kitagawa Utamaro*. ("Library of Japanese Art," No. 5.) Rutland, Vermont, 1956.

Lane, Richard. "The Beginning of The Modern Japanese Novel: Kana-zoshi, 1600-1682." *Harvard Journal of Asiatic Studies* (Cambridge, Mass.), Vol. 20, December, 1957.

———*Kaigetsudō*. ("Library of Japanese Art," No. 13.) Rutland, Vermont, 1959.

———*Masters of the Japanese Print: Their World and Their Work*. Garden City, 1962.

——"Saikaku's Contemporaries and Followers. The Ukiyo-zoshi, 1680-1780." *Monumenta Nipponica* (Tokyo), Vol. XIV, Nos. 3-4, 1958-1959.

——"Saikaku and The Japanese Novel of Realism." *Japan Quarterly* (Tokyo), April-June, 1957.

Ledoux, Louis V. *An Essay on Japanese Prints.* New York: The Japan Society, 1938.

Japanese Prints In The Collection of Louis V. Ledoux. Vol. I, The Primitives. New York, 1942; Vol. II, *Harunobu to Shunshō,* New York, 1945; Vol. III, *Bunchō to Utamaro,* New York, 1948; Vol. IV, *Sharaku to Toyokuni,* Princeton, 1950.

Michener, James A. *The Floating World.* New York, 1954.

——*Japanese Prints: From The Early Masters To The Moderns,* with notes on the prints by Richard Lane. Rutland, Vermont, and Tokyo, 1959.

Noguchi, Yone. *The Ukiyoye Primitives.* Tokyo, 1933.

Paine, Robert Treat and Soper, Alexander. *The Art and Architecture of Japan.* ("The Pelican History of Art.") Baltimore, 1955.

Reischauer, Edwin O. *Japan Past and Present.* New York, 1946.

Ruffy, A. W. *Japanese Colour Prints.* London: Victoria and Albert Museum, 1952.

Sansom, George B. *Japan: A Short Cultural History.* London, 1946.

——*The Western World and Japan: A Study in the Interaction of European and Asiatic Cultures.* New York, 1950.

Shibui, Kiyoshi. *Estampes Erotiques Primitives du Japon.* Tokyo, 1926.

Takahashi, Sei-ichiro. *Torii Kiyonaga.* ("Library of Japanese Art," No. 8.) Rutland, Vermont, 1956.

Toda, Kenji. *Descriptive Catalogue of Japanese and Chinese Illustrated Books in the Ryerson Library of The Art Institute of Chicago.* Chicago, 1931.

Trotter, Massey. *Catalogue of the Work of Kitagawa Utamaro in The Collection of The New York Public Library.* New York, 1950.

Vignier, Charles. *Estampes Japonaises Primitives . . . exposées au Musée des Arts Décoratifs en Fevrier, 1909.* Paris, 1909. (Vol. I of a six-volume work.)

Vignier, Charles, and Inada, H. *Harunobu, Koriusai, Shunshō. Estampes Japonaises: catalogue de l'exposition au Musée des Arts Décoratifs en 1910.* Paris, 1910. (Vol. II.)

——*Kiyonaga, Bunchō, Sharaku. Catalogue de l'exposition d'estampes Japonaises au Musée des Arts Décoratifs.* Paris, 1911. (Vol. III.)

——*Utamaro. Estampes Japonaises . . . exposées au Musée des Arts Décoratifs en 1912.* Paris, 1913. (Vol. IV.)

Vignier, Charles, Lebel, J., and Inada, H. *Yeishi, Chōki, Hokusai. Estampes Japonaises exposées au Musée des Arts Décoratifs en Janvier, 1913.* Paris, 1914. (Vol. V.)

——*Toyokuni, Hiroshige. Estampes Japonaises . . . exposées au Musée des Arts Décoratifs, Janvier, 1914.* Paris (1919?). (Vol. VI.)

Volker, T. *Ukiyo-e Quartet, Publisher, Designer, Engraver and Printer.* Leiden, 1949.

Warner, Langdon. *The Enduring Art of Japan.* Cambridge, Mass., 1952.

TECHNICAL INFORMATION

The full signature of the artist is transliterated in every entry. On the early prints the name of the artist is often preceded by words meaning "Japanese artist" or just "artist" and followed by words which are equivalent to our *fecit,* "drawn by" or "painted by."

The designation for a Japanese print indicates its approximate size, as listed below:

Bai-ōban	18 x 13 inches
Ōban	15 x 10
Aiban	13 x 9
Chūban	11 x 8
Hose-e	12½ x 5½
Koban	5½ x 4½
Tanzaku	14 x 4
Hashira-e	28 x 4½ (pillar print)
Kakemono-e	30 x 10

The earliest prints were printed in black and white only and are known as *sumizuri-e,* "ink printed picture." Then it became the fashion to color prints by hand with a predominance of *tan* (red lead) and *beni* (red extracted from safflower). These prints were called *tan-e* or *beni-e.* The next step was the *urushi-e,* "lacquer picture," where glue and brass particles were added to give a luster and sparkle in imitation of lacquerware. Around the early 1740's a way was found to register color blocks and a new two-color print called *benizuri-e,* "red printed picture" with the second color green, came into fashion. By overprinting, three or four colors were sometimes produced, but not until 1764 when full-color register was invented did the polychrome print with its extraordinary range of subtle colors appear.

The following color photographs are by Otto E. Nelson:
19, 47, 96.
The color photograph No. 50 is by Meriden Gravure.
The color photograph No. 57 is by George Waters Color Productions, Inc.
Catalogue designed by Virginia Field, Assistant Director, Asia House Gallery.
Produced by Fred M. Kleeberg Associates.